type

HOT designers make COOL fonts

HOT designers

t Y P e

by ALLAN HALEY

make COOL fonts

ROCKPORT PUBLISHERS, INC. ROCKPORT PUBLISHERS GLOUCESTER, MASSACHUSETTS

First published in the United States of America by:
Rockport Publishers, Inc.
33 Commercial Street
Gloucester, Massachusetts 01930–5089
Telephone: (978) 282-9590
Facsimile: (978) 283-2742

Distributed to the book trade and art trade in the United States by:
North Light Books, an imprint of
F & W Publications
1507 Dana Avenue
Cincinnati, Ohio 45207
Telephone: (800) 289-0963

Other Distribution by:
Rockport Publishers, Inc.
Gloucester, Massachusetts 01930–5089

ISBN 1–56496–317–9

10 9 8 7 6 5 4 3 2 1

Design by Visual Dialogue.

Printed in Hong Kong.

contents

Type Families

Post-it Notes and typeface families have a lot in common. Both are elegant solutions to everyday problems—it seems as though they have always been there for us, making life a little simpler—and the original concept of each has grown far beyond its simple beginnings.

It may seem as though typeface families have also been around forever; helping us organize our type libraries and create documents with consistent type styles. Truth is, the idea of a typeface family is, like that of Post-it Notes, a relatively new idea. OK, type families weren't invented in the last decade, or even in the last fifty years; but when you consider that type has been with us for more than five-hundred years and that the idea of a typeface family was only invented around the turn of the century, it's a relatively new idea.

No Solutions Are Necessary Where There Are No Problems

At first, typefaces were identified only by their sizes—which was all anybody really needed. Originally fonts weren't purchased as products, but manufactured by the individual printers who used them. Aldus Manutius had his own fonts, Garamond had his, and Bodoni had his. All Bodoni had to do to get the font he wanted was to call out to one of his workers, "Hey, Gino, get me that font of eight-point type." (Actually, the idea of standard type sizes didn't exist until the middle of the last century either, but that's another story.)

Over time some typefaces became vaguely linked to their designers or to the foundry that supplied the type. "That font of eight-point type" became "that font of eight-point Caslon type" or "that font of eight-point Baskerville type." But naming and organizing type and fonts wasn't all that important, because there weren't that many typefaces to worry about.

Type and Economics 101

But something happened in the middle 1800s; the Industrial Revolution was born, and with it came mass-produced products—products to be sold. Selling products meant advertising, and advertising, then as now, required new and special typefaces. The demand for new typefaces and the invention of the pantographic punch-cutting machine created a virtual explosion of new typeface designs. Type foundries hired large staffs of designers to create new typefaces to sell to eager printers, and type became big business. Typefaces with exotic names like Satanick, Kismet, and Chameleon began to flood the market. Along with these new, creative designs, however, came something else: copies of popular designs from other foundries. If one foundry released a new design called Clarendon, another might copy the design, change its proportions, and call the face Old Style Antique, while still another foundry might produce a similar design and call it by yet another name.

All these new typefaces were certainly confusing to printers of the day, but also—and more importantly in the history of type—the duplicates began to hurt the bottom line of the individual type foundries. Foundries could no longer count on a good return on their investments in new fonts. To solve this "business" problem, more than twenty individual type foundries merged in 1892 to form a new company called American Type Founders.

One of the goals of the ATF merger was to eliminate duplication of type development, marketing, and sales efforts—and the duplication of typefaces within the libraries of the member companies. In taking on this endeavor, however, ATF encountered another problem: making sense and a system out of all the typefaces inherited from the separate companies. The man who got the job of solving the problem was Morris Fuller Benton, son of the inventor of the pantographic punch cutter. With an invention of his own, the idea of a family of typefaces, duplicate fonts at the various ATF foundries, and all the other seemingly wild variations of type, suddenly began to find homes.

The Simple Solution

Benton's idea was that a family of type consists of a number of typefaces that show a marked resemblance but that have individual design variances. The members of a typeface family, although they may be varied and diverse, all show the basic characteristics of the parent design, in much the same way that brothers and sisters look like their parents. With Benton's invention of the type family, Thorne Fat Face, Full Face Roman, and Extra Condensed No. 4 all became part of the Bodoni family.

Benton sorted most of the inherited ATF typefaces into families, and later he expanded on his idea to create new families. The Cheltenham, Century, Cloister, and Stymie typeface families are just a few of the designs that Benton was directly responsible for. Other families, like Bernhard Gothic and Goudy, he commissioned from famous designers of the time. Most of Benton's type families, however, grew over time with little regard for design continuity within a family. The Cheltenham family is a good example—it grew from the two faces of the original release in 1904 to a family of twenty faces eight years later.

Benton's original idea has been modified and expanded on several times since the late 1800s. Type families have become larger, more diverse, and better thought-out.

Planning by the Numbers

To provide a full range of completely compatible variants, planned in an orderly fashion, the Swiss designer Adrian Frutiger designed a new kind of family in 1957. Since Frutiger thought that the traditional system of names (bold, semibold, semibold condensed, and so on) was confusing and outdated, he proposed a logical and systematic numbering scheme. In Frutiger's system, each typeface was given a two-digit suffix. The first digit classified the alphabet weight, the figure *3* indicating the lightest weights in the family and the figure *8* the boldest. The second digit identified the typeface proportion—higher numbers for condensed designs and lower numbers for expanded designs. In addition, if the second number was odd, the typeface was a roman design; and if it was even, the typeface was italic. Thus, Univers 39 is a very light condensed roman while Univers 56 is a medium-weight italic of normal proportions.

Extended Type Families

Some typeface families are made of different subfamilies. ITC Stone is a perfect example; its subgroups are Stone Serif, Stone Sans, and Stone Informal. Each design has roman and italic versions in three weights, for a total of eighteen individual typefaces. The three basic designs have the same cap heights, lowercase x-heights, stem weights, and general proportions. Each typeface has been designed to stand on its own as a useful communication tool, but it is also part of a large integrated family that can be mixed easily with other members of the family.

Test Tube Type Families

Recently, technology has also helped to expand the idea of typeface families. Multiple master technology from Adobe Systems Inc. enables a graphic designer to do something that was previously the exclusive domain of highly trained typeface designers—create customized fonts that maintain the integrity of a typeface design: new members of a type family. Using multiple master technology, a type designer creates master designs at each end of a design axis—such as "light" and "bold" or "expanded" and "condensed"—within a single electronic font. The end user, a graphic designer, can then generate intermediate variations of that typeface, between the master designs. Hundreds of variations can be created between the two extreme design masters.

Like Post-it Notes, the simple idea of a typeface family has grown into a suite of useful, and sometimes fun, products. Now if there was just a simple way to keep them from cluttering your desktop....

The Business of Designing Type: Cold Cash for Hot Fonts

First things first: no one gets rich designing typefaces. In fact, until recently, designing typefaces was a pretty good way to lose money. Technology and economics, however, have changed over the last several years. Today, because computers and software have democratized typography and type design, and because more people are buying and using fonts, typeface design can be a rewarding and profitable business venture. Typeface design isn't, however, an easy way to make a quick buck. It takes talent, creativity, and plain old hard work to earn a meaningful income designing type.

If you're not in it for the big bucks, aren't afraid of hard work, know a thing or two about what letters should look like, and want to give typeface design a try, you will still need to ask yourself several questions before embarking on a new typeface design.

Two Reasons for Designing a Typeface

The first question is: "Why do I want to design a typeface?" There are two basic answers to this question: make money and gain exposure.

MAKING MONEY Money can be made in three ways through typeface design: revenue or royalties from retail font sales (actually licenses, because fonts are technically not sold), royalties from OEM licenses, and payments for custom typeface design projects.

Revenue from retail font sales can come either in the form of payments from font foundries such as Agfa or Adobe and font resellers such as Font Haus or Phil's Fonts, or from direct sales to end users if you choose to market and distribute the fonts yourself.

Revenues can also come from OEM business relationships. The letters "OEM" stand for original equipment manufacturer, and the concept here is that your typefaces are licensed by software or hardware developers for inclusion as "bundled" fonts with their products.

Finally, money can be made designing fonts as part of a custom typeface design project. More and more companies are commissioning custom typefaces for their use—so much that many independent typeface designers are doing more custom work than producing designs on spec for retail sales.

GAINING EXPOSURE The other reason for designing a typeface is to gain exposure. While you should never settle for less than fair royalties for a typeface design because of promises of huge amounts of exposure for you and your typeface, don't underestimate the power of exposure to gain additional creative work. Many type designers confirm that the retail designs they produce are important to keep their names and work in the public eye. Whether you are a graphic designer, illustrator, or type designer, or you make your living in virtually any other of the graphic arts, typefaces are great "billboards" advertising you and your work.

Solving Design Problems

The next question you need to ask yourself is: "Where do I start?" Most successful typeface designers will tell you that the process of typeface design is, for the most part, solving a specific design problem. Whether it is designing a new text face that is space-efficient, creating a display design that stands out from the crowd, or combining the best attributes of two existing typefaces to satisfy the wishes of a corporate art director, virtually every new typeface, and clearly every successful typeface, is the result of an imposed design problem. If it isn't supplied by an outside source in the form of a design brief, impose a set of design parameters on yourself. Have a reason for attempting to create a new typeface.

If you are creating a typeface for retail sales, the next step is to look at the marketplace for your product. Look at what typefaces graphic communicators are using and be aware of design trends. Grunge fonts, for example, are fast becoming "yesterday's news." If you see that a lot of condensed typefaces are being used in ads and graphic design, but they are mostly sans serif designs, think about creating a family of condensed serif typefaces. If you are considering having one of the major font suppliers carry your typeface, look at what is in their font catalog. If a particular supplier has a large number of calligraphic scripts in its type library, it makes little sense to create another calligraphic script for the company. Look for "holes" in the spectrum of typefaces being offered and used—then fill the holes with your design.

Golden Rule of Typeface Design

If there is one rule for developing a financially successful typeface it is this: create a design that is both distinctive and versatile. The idea is to develop a typeface that stands out from the crowd—and one that can be used in a variety of different documents. Actually, this isn't as easy a proposition as it may sound. Just about anybody can draw a distinctive typeface; the problem is that the more distinctive a typeface design becomes, the less versatile it tends to be. Standing out in a crowd is not enough to insure that a font will sell; the typeface also needs to be a design that will be used a lot. Good examples of distinctive and versatile typefaces are Lithos from Adobe Systems Inc. and Pilsner, part of the Creative Alliance collection.

LITHOS Pilsner

Old Fonts vs. New Ideas

Think twice about creating a revival of an older typeface—in fact, think three times. At best, revival typefaces are problematic; most foundries shy away from licensing them, and they are hard to market if you decide to take on the whole business venture of fonts and font sales yourself. The problem is that typeface revivals are almost never totally successful. First, they generally appeal to a relatively sophisticated (read: small) audience. Designing typefaces for a limited audience virtually assures that you will have small sales. Next, typeface revivals almost always lack the warmth and verve of the original design, or are overly mannered in a slavish attempt to replicate all the idiosyncrasies of the older face. Cleaning up old metal typeface designs almost always strips them of their charm, and leaves in their place a flat, overly thought out, lifeless design. Attempting to replicate all the inconsistencies of old typefaces is an equally fruitless undertaking. The bumps and warts found on type in old documents were sometimes the random effects of the antique printing process, sometimes the fault of a less than attentive worker, and sometimes the result of a poorly cut or cast character. These flaws, however, often gave the printing a vitality and charm not found in modern documents. To attempt to copy all the imperfections of antique printing results in a selfconscious type that just looks, well, bumpy.

About the only time that revival typeface designs are a good idea is when the typeface is a relatively new design (within the last hundred years or so) and it has not already been updated to digital technology, or if you are modeling your work on the designs of an earlier master but have no intention of actually replicating the letterforms.

Whether the typeface is a revival, a new text design, or a cutting-edge display face, continually ask yourself the "why question": "Why would someone want to use this typeface?" The fewer answers you have to this question, the more difficult it will be to market the design and the less chance the typeface will be financially successful.

It Takes More Than ABC

Typeface design requires more than drawing the caps, lowercase, punctuation, and a set of numbers. The minimum number of characters required for most fonts is about two hundred and fifty. The standard that most people expect in a font is the ISO/Adobe character set. This includes the following characters.

ISO/Adobe character set

ABCDEFGHIJKLMNOP
QRSTUVWXYZabcdefgh
ijklmnopqrstuvwxyz&01234
56789ÆŒØæœfiflßÁÂÄÀ
ÅÃÇÉÊËÈÍÎÏÌÑÓÒÖÔÕ
ÚÙÜÛŸáâäàåıãçéêëèíîïìñóô
òõúûüùÿ^¨˙`˚~˛ˇ"©®™@†‡§₵
*¡?¿.,;:''""…«»()[]{}|/\-—
_˙/$¢£¥ƒ¤#%‰=+~<>¬°∧

example of revival face

Adobe Jenson

example of new face

Meta

The typeface should also be made available in both Macintosh and PC (Windows) font formats. Virtually every major supplier of fonts will ask for these two formats, and even if you only intend to market the fonts yourself, a growing number of Windows users are looking for new typeface designs.

Plan on providing full kern-sets with your font. Customers expect them, and font vendors require them. How many kerning pairs are in a full kern-set? To a large degree that depends upon the typeface design and how good a typeface designer you are. (Generally, the best typefaces require the least number of kerning pairs to sort out spacing problems.) Lots of kerning pairs (over a thousand) also make the font take up an inordinate amount of digital real estate and, more importantly, slow down the font's performance.

You will also need to do a quality assurance check on the fonts you create. Just because they work on your system doesn't mean that they will work on everybody's. Fonts that won't print or crash an application are obviously bad products; not only are they not used, but they also make customers think twice about purchasing your products again. Whether they are licensed to a font vendor or you sell them direct, fonts have to be industrial-strength.

Not Required, But Worth Considering

Think of the more than two hundred and fifty characters required in the ISO/Adobe character set as a minimum. Whether it's ligatures and old-style numbers for a text typeface, or swash and alternate characters for a display design, almost every typeface can benefit from an enlarged character set. These additional characters (at right) can make the typeface more versatile—and more appealing to type users.

Ligatures, old-style numbers, small caps, and other typographic niceties enable graphic designers to set better text copy with your font. Typeface-sensitive ornaments, symbols, or border elements are also appealing and useful typographic tools. Swash and alternate characters give graphic designers more flexibility in creating headlines with your typeface.

Not only will characters beyond the required minimum make a typeface more adaptable and more appealing to graphic designers, but if there are enough of them they can be sold as an additional font.

Font's Done, Now What?

Once the typeface has been created, the real work begins. For a typeface to be financially successful it must be packaged, marketed, advertised, and distributed, and technical support must be provided. These tasks can be taken on exclusively by the type designer, relegated to a font foundry or font reseller, or handled as a shared activity between you and a font supplier.

If you choose to take on all these endeavors yourself, there is both good news and bad news. The good news is that you will have complete control over the sales, marketing, and support of your products. The bad news is that you will have complete control over the sales, marketing, and support of your product. You will make all decisions in these matters. The end result of these efforts will be exactly what you put into them. If these are issues that you do not want to tackle, or if you are less than competent in these areas, the financial success of your products will suffer.

1234567890

Adobe Jenson old-style numbers

Adobe Jenson ligatures

ABCDEFGHIJKLMNOPQRSTUVWXYZ

Adobe Jenson small caps

ABCDEFGHIJKLMNOPQRSTUVWXYZ
abcdefghijklmnopqrstuvwxyz

Adobe Jenson swash characters

Adobe Caslon ornaments

Running with the Big Dogs

If you decide to work with one of the major font suppliers, there are a few things of which to be aware. First, they prefer exclusive arrangements—some demand them. An exclusive arrangement with a foundry or reseller usually means that that company has complete control over your typeface and that you cannot offer the design to another supplier. Some foundries temper this definition by allowing the owner of the typeface to also market and sell fonts of the design, making the arrangement more an exclusive distributorship than an exclusive license.

Foundries will license fonts on a non-exclusive basis, but it's the exclusive designs that get the most attention, exposure, and marketing effort. Licensing a typeface on a non-exclusive basis usually means that the design is just another of the products offered by the supplier. If you do a good job of marketing your designs and license to a number of suppliers on a non-exclusive basis, this can be as financially rewarding as an exclusive arrangement with one foundry—just remember that the key to success is good marketing.

Going for the Gold

Exclusive designs will also demand a larger royalty than non-exclusive designs—sometimes as much as twice as large. Exclusive typefaces can also earn advances against royalties. This almost never happens with non-exclusive typefaces. If you are prepared to license a typeface on an exclusive basis, you can expect royalties in the 15% to 25% range. advances, when they are available, range from $500 to $2500 per alphabet. In some cases, though, advances against royalties can reduce the amount of royalty provided. For example, a foundry may offer a 22% royalty for exclusive designs with no advance, and an 18% or 20% royalty for typefaces that get an advance payment against royalties.

There was a time when foundries offered one-time production fees in addition to royalty payments. Unfortunately, these have all but disappeared.

Royalties are paid on a font's transfer cost. This means that a designer's compensation will be dependent upon the actual selling, or transfer price, of the font. If a font is advertised for $39 dollars, but is sold as part of a special promotion for $29, the royalty is based on the latter number. If the foundry sells the font direct to the end user, the royalty is based on that selling price. If, however, the foundry sells the font through a reseller or distributor, the royalty is based on the transfer price from the foundry to the reseller—not the reseller's selling price. The bad news in this scenario is that the transfer price can be discounted as much as 50%

or 60% from the suggested retail price. The good news is that foundries that sell through resellers in addition to selling direct move a lot more merchandise than those that just sell directly to customers.

What to Expect

If you have licensed your typeface to a major foundry or large font reseller, you ought be able to count on a few things from your business relationship. You should expect the following:
- Notification of when your typeface is released to the public.
- Prompt payments, usually on a quarterly basis. Sometimes this can be twice yearly; it is almost never monthly.
- A record of font sales with your royalty statement.
- Credit for your designs in font catalogs and product lists. This may not happen, or even be possible, all the time, but it should certainly be more often than just at the time of product release.
- Someone to talk to if you have questions about your typeface—and someone who will tell you if there are problems with your design.

Things you should expect if you license your typeface on an exclusive basis include all of the above, plus the following:
- You and your typeface featured in company advertising and marketing programs. Your work will have to share time with the other exclusive designs in the company's type offering, but if a design is exclusive it should be promoted.
- Input into marketing and advertising programs. You won't be made an ad hoc marketing manager for your typefaces, but you should have a voice (if you want it) in how a company promotes your work.
- Guidance for improving the sales potential of your design. This can come in the form of suggestions to improve your design and/or ideas, such as adding additional characters, which will make your typeface more marketable.
- Samples of company advertising, marketing, and promotional materials sent to you on a regular basis.

Even though some companies promise all of the above, and genuinely try to fulfill their promises, companies are run by humans. Unfortunately, in most companies there are generally not enough humans employed to accomplish all the work that's required—and humans are not perfect. Remember, it's the squeaky wheel that gets the grease. If you are not getting the support or service you think you should, let people know.

It Takes Talent

In the words of British type designer Dave Farey, "There are two abilities required to become a typeface designer. The first is application, or stamina. It's slow, grinding work to solve the incidentals and foreign sorts for a type font. The other is talent. There are, perhaps, many talented designers who do not have the stamina, and many mediocre designers who turn out fonts with 256 characters in 144 different weights and versions—and are still boring alphabets."

The guidelines above are about application—talent is up to you.

"There are two abilities required to become a typeface designer. The first is application, or stamina. It's slow, grinding work to solve the incidentals and foreign sorts for a type font. The other is talent."

DAVID BERLOW

David Berlow entered the world of type design in 1978 as a letter designer for the Mergenthaler Linotype type foundry. In 1982, after working for Linotype for four years, he joined the newly formed digital-type supplier Bitstream, Inc. Berlow left Bitstream in 1989 to found the Font Bureau, with Roger Black. To date, the Font Bureau has developed more than two hundred custom type designs for organizations like the *Chicago Tribune*, the *Wall Street Journal*, *Entertainment Weekly*, *Newsweek*, *Esquire*, *Rolling Stone*, and Hewlett-Packard. The Font Bureau also has a retail type library consisting of over five hundred typefaces.

Armed with state-of-the-art computer hardware, software, modems, ISDN lines, and e-mail, Berlow has been able to move his business from downtown Boston to Martha's Vineyard. Business continues as usual, but now Berlow can enjoy living on one of the most picturesque coastal islands in America.

Traditional Values with an Eye to the Future
With his typographic tastes tending toward the traditional, Berlow was quoted in *U&lc* magazine on his thoughts on the future of typeface design: "Legibility will continue to be challenged, as it has always. In the old days, however, legibility was challenged by obscuring type with elaborate florals and other organic matter. Today, there is an urban, street-stomped, road-kill kind of font that is challenging legibility; it's more violent. The publishing community will continue to adopt this look because there's a market for it, but of course, there will always be people who will respond to classic typography."

Belucian Book

Bureau Grotesque specimen
© The Font Bureau Inc.

SPOOKY NOISES
ARE HEARD THROUGHOUT THE OLD MANSION
Euclidean Theorems
EXPLAIN THE STRUCTURE AND BEHAVIOR OF THINGS
❧INTERIM❧

Berlin Sans specimen © The Font Bureau Inc.

Working Tools

Like most type designers, Berlow uses a Macintosh as his primary design tool. "Actually, I have two Macs," he says. "One is a 21-inch (53 cm), 72-dpi color monitor. This has a huge disk drive and a modem, on which I receive, compose, and send e-mail, and design with type. From cards for friends and plots for gardens to testing new typeface designs and applications, this Power Mac 8100 is the machine." Berlow goes on to explain, "Beside this machine sits a rather frumpy Quadra 800 with a monochrome monitor. But the monitor is actually a secret weapon. It has 120-dpi screen resolution and shows lines and filled type shapes in crystal clarity. This machine, with a modest amount of RAM, speed, and bit depth, is where I design and engineer typeface designs."

Berlow's software of choice is Macromedia Fontographer. "I use Fontographer 3.5.2 beta 3 for most of my drawing work, but I also use Fontographer 4.1," he says. The reason for using two versions of Fontographer? "3.5 presents the drawing and spacing of type in a way that is similar to the paper and pencil tools with which I learned type design. 4.1, however, also allows wonderful batch processing of things you need to do to outline fonts, like interpolation and path error finding."

Berlow's thoughts on the design process run counter to the adage that good design is ten percent inspiration and ninety percent perspiration. "First," says Berlow, "there is a long period of listening, either to the inner voices or to a client. Then there is a long period

of thinking, toying with various parts in one's head, sketching a bit here or there, and then thinking again. Finally, when thinking will take you no further without massive visual evidence, drawing occurs. This is usually the very smallest part of the process. Once fifty to sixty characters have been done, usually after a couple of days of steady work, the design process begins to morph into a production process where it might end a week or a month later, depending on the final size of the family."

Berlow is one of the most technically aware type designers—and one of the most tuned-in to what is happening with the major font technology providers. Asked about his view on the future of the type-design business, his reply is, "Foggy, for sure. There will always be a type business, but if the future's anything like recent past, we're in for interesting times. Font formats, wide-area networks, aesthetic thresholds, and bandwidth all have so much to do with the business that it's impossible to tell."

modern printing of old
metal typeface

MASSAC
ostmodern Pythagorean Theorem
ecreational Vehicles
E BACKWOODS AND DIRT ROADS OF TENNESSEE & KENTUCKY
ICTURESQUE VIEW

LE SEVL DIVIN EST PERDVRABL
TOVTE AVTRE CHOSE
EST PERISSABLE.

TOvt ce qui eſt creé & imprimé de Dieu,
Pour vivre en luy, ô Prince & Princeſſe d'Oran
Teſmoigne par effect le naturel du lieu
D'où il provient, & là ¸ ſon tour fini ¸ ſe range.

Le terreſtre ça bas & le celeſte en haut
¸ Selon l'ordre divin ¸ faut touſiours qu'il retou
Ce qui eſt outre plus n'eſt qu'arrogance, & fa
Qu'il s'abiſme en la mort, quelque temps qu'il

Heureux donques celuy, qui ſelon le conſei
De Ieſus qui l'aſſiſte à ſoy meſmes renonce,
Rangeant ſa volonté, effort & appareil

Throhand

Throhand was the first typeface created for the Creative Alliance, and Berlow was one of the first type designers Agfa approached to work on the project. Given virtual carte blanche in the design of this typeface, Berlow expressed a desire to base his work on research at the Plantin Moretius Museum in Antwerp, Belgium. Berlow knew the museum to be a storehouse of untapped design inspiration. Agfa agreed, sending Berlow off to Belgium to begin his work on the new typeface.

Berlow created three versions of Throhand: Pen, representing the original design; Regular, representing the type molds; and Ink, which is akin to the final results of metal type printed on paper. Berlow discovered the basis for Throhand's italic designs in a set of matrices on display in one of the less-traveled public area of the museum. Berlow recalls "I spent a morning washing them with a toothbrush and kerosene, letter by letter, until I could see what they really looked like."

The Throhand family was completed early in 1995, after just six weeks. It now serves as one of the cornerstones of the Creative Alliance typeface library.

Throhand Pen
Throhand Regular
Throhand Ink

Throhand

STORIED
PEN ROMAN
ROMAN TIES
PEN ROMAN
Dogmatic Institution
PEN ROMAN
5 Effusive Descriptions
PEN ROMAN EXPERT
Stark Mysterious Amazon Slope
REGULAR ITALIC EXPERT
Listed prices are beyond reasonable limits
REGULAR ITALIC
HISTORIES
REGULAR ROMAN
ROMAN TIES TO DOCUMENTS
REGULAR ROMAN
Tales of Manchurian candidate battles emerge from the controversy
REGULAR ROMAN
Constitution Amendments Threaten Technological Cases
REGULAR ROMAN EXPERT
Checks on influence placed an affiliation between Institute For Ethics and Court
REGULAR ITALIC
PRACTICAL INSPIRATION FROM UPPER PENINSULA
INK ROMAN
Potent renditions called "standard-setting" by industry and entertainment mogul
INK ROMAN
Rescued from Sequential Access Memory the Computer Industry Flowers
INK ROMAN EXPERT
The artful play elicited the warmest imaginable response from the overwhelmingly receptive academy class
INK ITALIC
Accessories available under warrantee only for length of time as required by purchasers to return to homes
INK ROMAN

In 1995, David Berlow was commissioned by Agfa to design a typeface based on a research visit to the Museum Plantin-Moretus in Antwerp. Berlow designed this family, in a tight range of weights, to address the issue of modern versus letterpress printing techniques, with respect to sixteenth-century types. Throhand follows several of the museum's specimens, including works by Garamond, Van Den Keere and unknown cutters; FB 1995.

Pen Roman, Pen Roman Expert, Pen Italic, Pen Italic Expert, Regular Roman, Regular Roman Expert,
Regular Italic, Regular Italic Expert, Ink Roman, Ink Roman Expert, Ink Italic, Ink Italic Expert

Regular Roman with Italic, Expert and Italic Expert

GRUMPY WIZARDS MAKE A TOXI *BREWS FOR THE EVIL QUEENS AND* jack. Lazy movers quit hard packing of the papier-mâché jewelry box. Back in my quaint garden: jaun ty zinnias vie with the flaunting phlox. *Hark! 4,872 toxic jungle water vipers quietly drop on zebras for meal!* New farm hand (picking just six quinces) proves st rong but lazy. For only $65, jolly housewives made "inexpensive" meals using quick-frozen vegetables. Jaded zombies acted quaintly, but kept on driving their 31 oxen forward. Will Major Frank Douglas be expected to take this true-false quiz very soon? JIMMY AND ZACK, THE POLICE EXPLAINED, WERE LAST SEEN DIVING INTO BIG FIELDS OF BUTTERE QUAHOGS. Six big juicy steaks sizzled in a pan while five workmen left the quarry. The mad boxer shot his quick, gloved jab to the jaws of his dizzy opp onent. The jukebox music puzzled the gentle visit itor from a quaint valley town. Waltz, nymph, for quick jigs vex Budd. Just work for some improved basic technique to maximize your new typing skill *When we go back to Juarez, Mexico, do we fly over pic uresque Arizona?* Sixty zippers were picked quickly from the lovely woven jute bag. Murky haze enve loped the city as jarring quakes broke about forty six windows. Nancy P. Bizal exchanged vows with Robert J. S. Kumpf at Quincy Temple. The quick brown fox jumps over that lazy dog. Pack my box with the five dozen liquor jugs. Brick quiz whangs jumpy veldt foxes. Quick wafting zephyrs vex bold James. Sphinx of black quartz, judge my vow. The five boxing wizards jump so quickly. Pickled, Gor bachev jumps the tawny fax quiz. SYMPATHIZING WOULD FIX QUAKER OBJECTIVES. *DOXY WITH CH ARMING BUZZ QUAFFS A BIG VODKA JULEP.* RAVING ZIBET CHEWED ON CALYX OF PIPSQUEAK MAJORS. Grumpy wizards make toxic brew for the evil quee and jack. Lazy movers quit the hard packing of pap ier-mâché jewelry box. Back in my quaint garden: jauny zinnias vie with the flaunting phlox. Hark! 4,872 toxic jungle water vipers drop onto zebras fo

Ink Roman with Italic, Expert and Italic Expert

GRUMPY WIZARDS MAKE A TOXI *BREWS FOR THE EVIL QUEEN AND* jack. Lazy movers quit hard packing of the papie mâché jewelry box. Back in my quaint garden: jau nty zinnias vie with flaunting phlox. *Hark! Those 4,872 toxic jungle water vipers quietly drop onto the zeb ras for meals!* New farm hand (picking just six qui nces) proves strong but so lazy. For only $65, joll housewives made "inexpensive" meals using quick frozen vegetables. Jaded zombies acted quaintly b but kept driving the 31 oxen forward. Will Major F. Douglas be expected to take this true-false quiz very soon? JIMMY & ZACK, THE POLICE EXPLAIN INED, WERE LAST SEEN DIVING INTO A FIELD OF BUTTERED QUAHOGS. Six big juicy steaks sizzled in a pan as five workmen left the quarry. The mad boxer shot a quick, gloved jab to the jaw of his diz opponent. The jukebox music puzzled the gentle visitor from a quaint valley town. Waltz, nymph for quick jigs vex Budd. Just work for improved basic technique to maximize your new typing skill *When we go back to Arizona, do we fly over picture uresque Juarez, Mexico?* Sixty zippers were picked quickly from the woven jute bag. Murky haze env eloped a city as jarring quakes broke about forty-six windows. Nancy P. Bizal exchanged vows wi Robert J. Kumpf at Quincy Temple. The quick brown fox jumps over the lazy dog. Pack my box with five dozen liquor jugs. Brick quiz whangs ju mpy veldt foxes. Quick wafting zephyrs vex bold James. Sphinxes of black quartz, judge my vows. The five boxing wizards jump so quickly. Pickled, Gorbachev jumps the tawny fax quiz. SYMPATH HIZING WOULD FIX QUAKER OBJECTIVES. *DOXY WITH CHARMING BUZZ QUAFFS A BIG VODKA JULEP.* RAVING ZIBETS CHEWED CALYX OF PIPSQUEAK MAJOR. Grumpy wizards make toxic brew for the evil queens and jacks. Lazy movers quit the hard packing of papier-mâché jewelry boxes. Back in my quaint garden: jaunty zinnias vie with the flaunting phlox. Hark! 4,872 toxic jungle water vi

ABCDEFGHIJKLMNOPQRSTUVWXYZabcdefghijklmnopqrstuvwxyz&ffffiffifffifl
§¶$£¥¥#ƒ0123456789%‰¢°=‹‹›'’‘/¿?¡!&()[\]{}*-.,:;...«»◊"”"‹‹.„_•†‡@®©℗™√▮◣
§¶$£¥¥#ƒ0123456789%‰¢°=‹‹›'’‘/¿?¡!&()[\]{} ABCDEFGHIJKLMNOPQRSTUVWXYZ
áàâäåãçéèêëíìîïñóòôöõøœúùûüyÁÀÂÄÅÃÆÇÉÈÊËÍÌÎÏÑÓÒÔÖÕØŒÚÙÛÜÝ

Proportional oldstyle figures in Roman – Proportional lining figures in Expert – Special: &stzk

Throhand specimen

Throhand text samples
© The Font Bureau Inc.

a b c d e
f g h i j k
l m n o p
q r s t u
v w x y z

TYPEFACES

Rhode™

The creation of Rhode proved to be a different sort of process. According to Berlow, "With the design of Rhode, I was free to roam, and chose something I liked that wasn't done."

One of Berlow's design goals was to create a sans serif family that was a square design in the condensed variants and got rounder as character proportions became more extended. Another design goal, which posed a particularly difficult design challenge, was keeping the vertical strokes optically the same weight as the horizontal stems of the alphabet.

The completed design is "a spicy, industrial strength, flatsided-fatheaded accompaniment to many of the less flavorful, but more readable/legible sans serifs of our print and online times." Rhode is a large family of type, currently with sixteen weights and variants, although Berlow has a habit of adding to his work as customer demand, or his whim, warrants.

Rhode with Franklin Gothic

IN THE KNOW
Wary travelers avoid higher altitudes
Upon arriving in such exotic destinations as Mexico

Rhode with Helvetica

Jumppin'
On stage, "Live" with the Rolling Stones & Co.
Though likely not to stir the same fevers the 60's and 70' brought

Rhode with Trebuchet

Running Rivers
Citizens help with wildlife management
not to imagine that management needs much help these days, but foes abound.

Rhode specimen

CONSTRUCTION
SEMIBOLD EXTENDED

Road Crew
BOLD CONDENSED

BUMP
BLACK EXTENDED

Rhode specimen
© The Font Bureau Inc.

DIESEL
BLACK NORMAL

LEAD CONTENT
MEDIUM EXTENDED

Combustion
SEMIBOLD CONDENSED

LOW OCTANE
SEMIBOLD WIDE

VISCOSITY BREAKDOWN
BLACK WIDE

MECHANIC
MEDIUM CONDENSED

Socket Wrench
BLACK CONDENSED

Gearbox Broken
BOLD WIDE

© The Font Bureau Inc.

Technology Lags

Duplexing Typefaces

Because machine-set metal type used a font magazine to hold the molds for individual characters, and a typesetting machine could hold only one font magazine at a time, many typefaces were developed that shared common character widths for various members of the type family. This allowed two or more letters to be put onto a single matrix. These typefaces were identified as duplexed (two variants containing the same character widths), triplexed (three variants containing the same character widths), and quadraplexed (four variants containing the same character widths).

While multiplexing typefaces were a boon to print production, they became the bane of type designers, who were forced to create italic typefaces that were too wide and bold designs that were too condensed.

Because the early phototypesetters had to duplicate the output of metal typesetting machines, these duplexed, triplexed, and quadraplexed typeface designs were replicated to produce phototype fonts.

With the advent of digital fonts the need for duplexed, triplexed, and quadraplexed typeface designs ceased. Virtually none of these designs exist as digital fonts on the current market.

Resolution Points and Light Traps

Early phototypesetting technology had numerous deficiencies that inhibited character imaging. Two common results of these deficiencies were the rounding-off of square corners and filling-in at places where two or more character strokes converged. To overcome these shortcomings, typeface designers added what were called resolution points to the square corners of letters and light traps to places where character strokes converged. These techniques were essentially design overcompensations that produced acceptable reproduction of the characters. As phototypesetting technology improved, and then as digital typesetting became the norm, these design techniques were no longer required to produce acceptable results. In fact, typefaces that incorporated resolution points and light traps no longer produced acceptable results because these overcompensations became visible in imagesetter output.

Light traps of Bell Centennial

Matthew Carter

Mantinia specimen

Matthew Carter is one of the few type designers who has made fonts for metal typesetting, phototypesetting, and the digital medium. His career began when he was between secondary school and Oxford University. It was at this time that he took an internship at the Enschedé type foundry in the Netherlands. The idea was for him to rotate through many of the departments in the company, acquiring a basic knowledge of the facets of the printing and typefounding business. Instead, when Carter arrived at the punch-cutting department, he stayed, learning this craft from P. H. Rädish, one of the twentieth-century masters. Carter has been designing type ever since.

Upon his return to London in 1957, Carter discovered that while there was demand for his talent and skill as a type designer and lettering artist, there was little call for the craft of punch cutting. "I'm not sorry that I began by learning to make type before learning to design it," recalls Carter, "but I would not necessarily recommend it to a student nowadays."

Freelance to Staff Designer

Carter did freelance lettering and typeface design for several years. In 1963 he joined Crosfield Electronics,

the British manufacturing agent for the Lumitype phototypesetting machine. This job regularly took him to Deberny and Peignot in Paris, where the Lumitype fonts were made. There, the type-drawing office was under the direction of Adrian Frutiger, the designer of Univers, Serifa, Frutiger, and other noted typefaces. It was in this environment, Carter says, that he started making proper production drawings for the manufacture of fonts of type.

Two years later, Carter moved to New York to work for Linotype. Over the next twenty years, Carter built one of the industry's largest and richest phototypeface libraries. His partners in this endeavor were Mike Parker, who was in charge of typographic development, and Cherie Cone, who managed the font production department. In 1981, Carter, Parker, Cone, and another Linotype employee left the company to found Bitstream, the first independent digital type foundry.

Over the next several years, Bitstream evolved from a small, entrepreneurial start-up into an established company with a strong reputation for delivering quality products. Unfortunately, the work of building a company left little time for Carter to create new typeface designs. Because he had completed his work there

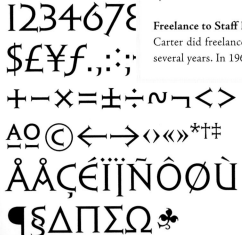

Sophia specimen

Mantinia specimen

MANTINIA

There is no display version of ITC Galliard:

·LING·CAPITALS

it was designed as a text face in four weights.

RE·DESIGNED

At headline sizes the serifs can look rather heavy—

TO·WORK·WELL

just as at small sizes those of Mantinia look light:

WITH·GALLIARD

This is 14 pt Galliard with 48 pt Mantinia:

AS·A·TEXT·FACE

SOPHIA WAS DESIGNED BY
MATTHEW CARTER.
IT WAS SUGGESTED BY HYBR
ALPHABETS OF CAPITALS,
UNCIALS AND GREEK LETTER
FORMS FROM 6TH-CENTUR
CONSTANTINOPLE.
SOPHIA WAS FIRST SHOWN,
TOGETHER WITH FACES BY
IA LICKO & ED FELLA,
N QUARTERLY' № 158

Sophia specimen

and sought to rediscover his roots as a typeface designer, Carter left Bitstream in 1991 to found Carter & Cone Type, with Cherie Cone.

Carter & Cone

There are two sides to the Carter & Cone business. The first is producing typefaces and fonts for retail sale." This is a matter of developing new type designs on a speculative basis and offering them for sale, directly from us or from one of the retail font outlets," Carter explains. "This side of the business is a long-term investment, in that it's bound to take some time for a retail typeface to turn a profit."

The other side of the business Carter refers to as contract work. "In this case we receive commissions from clients who may be magazines, newspapers, software developers, or virtually any company that sees value in having a typeface developed for their particular needs." Carter goes on to add that there are advantages and disadvantages to this side of the business. While commissioned typefaces don't pose the risk associated with speculative for-sale typeface designs, the commissioned fonts don't provide ongoing income because they are licensed outright for a one-time fee. To counter this downside, Carter stipulates in his contracts that after a period of time the rights to a typeface revert back to Carter & Cone. If there is no chance of this happening, as with the core typefaces Carter created for Microsoft, he charges an accordingly higher rate.

ntographer and QuarkXPress. The renderings he creates are scanned into the system with an Apple flatbed scanner at 300 dpi, and final characters are tested on a Apple LaserWriter 12/640 printer.

Hints for Designers

Carter offers a couple of hints for digitizing type: "There are some rules for placing control points in PostScript. The software prefers that they be placed at the extremes of curves (due north, south, east, west), which helps the PostScript rasterizer recognize certain important features when it hints characters for reproduction at low resolutions." Carter also adds, "It's

Mantinia specimen

TALL CAPI
H
LIGATURES
THV(
TUTWTYMEMPMDMBE
ALTERNATIVES
AOT&YRRQQ

Mantinia specimen

MANTINIA
DESIGNEI
CARTER • ANI
TO • ANDREA
ARTIST • ANI
MANTEGNA
ENGRAVEI
EPIGRAPHIC
OF • ANCEN
REVIVED • B

1992
Elephant

1993
Mantinia
Sophia
Time
Caledonia

1994
Big Caslon
Skia
Interchange
Walker

1995
Wiredbaum
Alisal
Tahoma

1996
Sokin-tai
Verdana

1997
Miller

generally easier to manipulate the shape if you use fewer control points. This comes up constantly when I'm teaching, because students think that more control points gives them more management—exactly the opposite is true."

Though steeped as he is in the history of lettering and type design, Carter does not lament the passing of the old ways. "You can't work roughly on a computer the way you can sketch on paper. But you can very quickly throw letters together from bits and pieces of other letters, to get an idea of shapes, sizes, and basic proportions. It's a different form of sketching; you can go through a lot of possibilities very quickly with a computer. The real power of working on a computer, though, is that you've got a printer hooked up to it. It used to be that you would have to wait days to get back type back from the type shop—now you can immediately see, as you add a character to the set, what it looks like. The loop is closed."

♠ T Y P E F A C E
Y ♠ M A T T H E W
D E D I C A T E D
M A N T E G N A
N T I Q U A R Y.
A I N T E D ♠ &
H E ♠ R O M A N
E T T E R I N G
M O N U M E N T S
H U M A N I S T S

Mantinia specimen

Big Caslon specimen

48 pt. THE BIGGER faces are oddly different in style. In his 1734 specimen Caslon showed several titling caps. Some of these were later given lowercases, one being adopted from an older face by Joseph Moxon. Of the sturdy romans that resulted, the two largest are particularly

Charter

Charter was the first original typeface released by Bitstream, Inc., and it was one of the first typefaces to expressly take into account the requirements of low-resolution laser printers. In creating this font, Carter followed traditional sixteenth-century roman types in proportion and form, but he added some very original traits of his own to this basic concept. Charter's relatively narrow capitals and the angled weight stress in the lowercase bowls are similar in form to late Oldstyle typeface designs developed in France.

Charter is by no means a simple revival of sixteenth- and eighteenth-century French fonts. It incorporates three additional design features not found in Oldstyle typefaces: narrow proportions, allowing for economical use of space; a generous x-height, improving readability at small point sizes; and sturdy, open letterforms that insure legible output at all resolutions.

Charter comes close to being a perfect example of Beatrice Warde's metaphor for a good type: one that, like a crystal goblet, allows the content to be more important than the container.

Bitstream Charter Bold

abcdefghijklmnopqrstuvwxyz
ABCDEFGHIJKLMNOPQRSTUVWXYZ
& ÆÐŁŒØÞ åæçðèfiflíïjłñœøßüþð
1234567890 1234567890 £$¢ƒ%
.,:;-'"!?«»()[]{}*†‡§

abcdefghijklmnopqrstuvwxyz
ABCDEFGHIJKLMNOPQRSTUVWXYZ
& ÆÐŁŒØÞ åæçðèfiflíïjłñœøßüþð
1234567890 1234567890 £$¢ƒ%
.,:;-'"!?«»()[]†‡§*

C

8 point
Bitstream is an independent digital typ
dry. Using the latest computer graphics
Bitstream's designers maintain the trac
l essentials of good type design, contro
hape, weight and spacing rhythm to pro
digitized letterforms of the highest qual

9 point
Bitstream is an independent digital typef
ry. Using the latest computer graphics to
Bitstream's designers maintain the tradi
essentials of good type design, controllir
ape, weight and spacing rhythm to produ
gitized letterforms of the highest quality
font formats. In addition to making defin

10 point
Bitstream is an independent digital typefo
ry. Using the latest computer graphics too
itstream's designers maintain the traditio
ssentials of good type design, controlling
e, weight and spacing rhythm to produce
ized letterforms of the highest quality in al
t formats. In addition to making definitive
ions of existing faces, Bitstream introduces

11 point
Bitstream is an independent digital typefour
Using the latest computer graphics tools, Bi
eam's designers maintain the traditional ess
als of good type design, controlling shape, w
ht and spacing rhythm to produce digitized
erforms of the highest quality in all font forn
In addition to making definitive versions of e
ing faces, Bitstream introduces creative new

12 point
Bitstream is an independent digital typefoundr
Using the latest computer graphics tools, Bitstr
m's designers maintain the traditional essentia
f good type design, controlling shape, weight a
spacing rhythm to produce digitized letterform
f the highest quality in all font formats. In addi
n to making definitive versions of existing faces,
tstream introduces creative new designs. Bitstre

14 point
Bitstream is an independent digital typefoundr
Using the latest computer graphics tools, Bitstr
m's designers maintain the traditional essentia
of good type design, controlling shape, weight
d spacing rhythm to produce digitized letterforr
of the highest quality in all font formats. In add

18 point
Bitstream is an independent digital typefoun
y. Using the latest computer graphics tools, B
stream's designers maintain the traditional e
entials of good type design, controlling shape,
eight and spacing rhythm to produce digitized

24 point
Bitstream is an independent digital typef
undry. Using the latest computer graphic:
tools, Bitstream's designers maintain the t
aditional essentials of good type design, cc

Charter Bold specimen

Charter family

...eam Charter Black

fghijklmnopqrstuvwxyz
ÆFGHIJKLMNOPQRSTUVWXYZ
ŁŒØÞ åæçdèçfiflíijłñœøßüþð
67890 1234567890 £$¢ƒ%
?«»()[]{}*†‡§

fghijklmnopqrstuvwxyz
ÆFGHIJKLMNOPQRSTUVWXYZ
ŁŒØÞ åæçdèçfiflíijłñœøßüþð
67890 1234567890 £$¢ƒ%
?«»()[]†‡§*

C

Charter Black specimen

8 point

Bitstream is an independent digital type foundry. Using the latest computer graphics tools, Bitstream's designers maintain in the traditional essentials of good type design, controlling shape, weight and spacing rhythm to produce digitised lette

9 point

Bitstream is an independent digital type foundry. Using the latest computer graphics tools, Bitstream's designers maintain in the traditional essentials of good type design, controlling shape, weight and spacing rhythm to produce digitised letterforms of the highest quality in all font form

10 point

Bitstream is an independent digital typefoundry. Using the latest computer graphics tools, Bitstream's designers maintain the traditional essentials of good type design, controlling shape, weight and spacing rhythm to produce digitized letterforms of the highest quality in all font formats. In addition to making definitive versions

11 point

Bitstream is an independent digital typefoundry. Using the latest computer graphics tools, Bitstream's designers maintain the traditional essentials of good type design, controlling shape, weight and spacing rhythm to produce digitized letterforms of the highest quality in all font formats. In addition to making definitive versions of existin

12 point

Bitstream is an independent digital typefoundry. Using the latest computer graphics tools Bitstream's designers maintain the traditional essentials of good type design, controlling shape, weight and spacing rhythm to produce digitized letterforms of the highest quality in all font formats. In addition to making definitive versions of existing faces, Bitstream int

14 point

Bitstream is an independent digital typefoundry. Using the latest computer graphics tools, Bitstream's designers maintain the traditional essentials of good type design, controlling shape, weight and spacing rhythm to produce digitized letterforms of the highest qu

18 point

Bitstream is an independent digital typefoundry. Using the latest computer graphics tools, Bitstream's designers maintain the traditional essentials of good type design controlling shape, weight and spacing rhy

Bitstream is an independent digital typefoundry. Using the latest computer graphics tools, Bitstream's designers maintain the traditional essentials of

Bitstream Charter

36 point

Charter
Charter

48 point

Charte
Charte

60 point

Chart
Chart

72 point

Char
Char

Bitstream Charter Bold

36 point

Charter
Charter

48 point

Charte
Charte

60 point

Char
Char

72 point

Cha
Cha

Bitstream Charter Black

36 point

Charter
Charter

48 point

Chart
Chart

60 point

Char
Char

72 point

Cha
Cha

Alisal

A design that Matthew Carter worked on for many years, Alisal would probably be classified as an Italian Oldstyle design. Alisal has nearly all the classic Italian Oldstyle character traits. It is more calligraphic in nature and has more of a marked pen-drawn quality than faces like Palatino or Goudy Oldstyle. Such typefaces were originally created between the late fifteenth and mid-sixteenth century in northern Italy and are some of the first roman types.

The first trial renderings of Alisal were done in pencil. When Carter was asked to complete the design for the Creative Alliance, he says, it had been so long since he worked on the design that it was almost as if he were doing a historical revival of his own typeface.

Palatino
Alisal

Type Families

When typefaces were first invented, there was no such thing as a family of type—there were just roman fonts. Then, in the early sixteenth century the idea of a cursive, or italic (named after Italy, where the idea was popularized) type was invented. But still there were no typeface families; italics were one style of type and romans were another. In the late 1700s, foundries began to release fonts in families—with roman and italic designs that matched each other in style. Later, the concept of typeface weights and proportions became popular. In the twentieth century, type families were enlarged even further by adding different designs to the concept. Designers began to create typeface families made up not only of roman and italic faces in various weights and proportions, but also of complementary serif and sans serif or differing serif designs.

abcdefghijklmnopqrstuvwxyz

Alisal

abcdefghijklmnopqrstuvwxyz

Alisal Italic

abcdefghijklmnopqrstuvwxyz

Alisal Bold

ABCDEFGH
IJKLMNOPQRSTUVWXYZ
ÆŒ&ÇØ
abcdefghijklmnopqrstuvwxyz
æœffffiflffifflßçø
12345678901234567890$$£¢
«(.,:;'?¿!i†["§"]‡%*/--)»

First version of ITC Cerigo Italic

DESIGNER

Jean-Renaud Cuaz

Jean-Renaud Cuaz's college education netted him a B.A. in science rather than in the arts, but this was quickly followed by four years of study at Supérieure d'Arts Graphiques in Paris. It was there that Cuaz was exposed to some of France's most talented and hard-working graphic educators—and to scores of past issues of *U&lc*, created by the late Herb Lubalin. According to Cuaz, both were instrumental in his decision to become a typographic designer.

In 1985 the Atelier National de Création Typographique was founded within the walls of Imprimerie Nationale in Paris. Dedicated to teaching its students the art and craft of typeface design, Cuaz was one of the first artists to attend the newly opened institution. There, he studied under such eminent French type designers as Ladislas Mandel and José Mendoza, whom Cuaz credits for much of his own current skill.

Freelance graphic and typeface design assignments have become the mainstay of Cuaz's professional work. One regular assignment in Chicago became so frequent that Cuaz eventually moved there, and he resides there still.

Cuaz has a somewhat unusual approach to beginning a new typeface design. "When I find an idea for a new typeface," he explains, "I draw a few letters on paper, two-inch [5 cm] cap height, and put them away in a research drawer for one month to one year. A certain time is needed to see if, looking again at these first strokes, they were indeed good ideas and could be improved, or they will end up in the most useful of designer's tools, the garbage bin."

If the initial sketches survive the aging process, Cuaz begins drawing the new typeface. The first letters he renders are usually lowercase "a," "e," "g," "n," "o," "p," and "s." With these foundation characters established, Cuaz uses Macromedia Fontographer to develop the rest of the alphabet. He then uses Fontographer's copy-and-paste features to create new letters from similar ones to quickly generate a temporary font. "Then," according to Cuaz, "I use QuarkXPress to

ITC Cerigo Medium

1982
Guimard
Initiales

1984
Mermoz

1985
Cavale
Artmedia

1986
Nautica

1987
Bellini Script
Socopa
Setori

1992
Gourmet
Script
Pechiney

1993
ITC Cerigo
Fleur-de-lis
Feria
Perrin

1994
Quattrocento
 Uno
Quattrocento
 Duo

1995
Typorium
Typorium LP

1996
Galena
Augustal
Augustal
 Corsiva
Stanica
Stanica
 Lyrica
Peplum
ITC Ellipse

make a page that displays 430-point letters with base and vertical lines marking space between two letters. I usually type two or three letters in a horizontal page, marking the space distance, and then I output the alphabet from my printer. The alphabet is then put together on 28" x 7" [71 cm x 18 cm] horizontal boards aligned inside ten-foot-long tracks on a wall in my studio. Displaying the twenty-six roman letters on a wall, with the italic or bold version under it, enables me to judge and correct the details, and using a reducing lens, to see how the typeface behaves scaled down." It is interesting to note that in this day of bits and bytes, Cuaz's process of designing and editing is exactly the way typefaces for metal and photo composition were produced decades ago.

Typeface design is a long and meticulous process for Cuaz. "From varying a serif length or an ending stroke to modifying the thickness of an ascender, little by lit-

tle, the typeface begins to live. The letters, once the result of a cold repetitive process, now harmonize. Each time corrections are brought to the design, the displayed alphabet is updated, to the point of satisfaction."

Cuaz has this advice for aspiring typeface designers: "I consider myself very fortunate having studied typeface design under Ladislas Mandel and José Mendoza for two years at the National Printing Office in Paris. This short but rich experience makes me suggest to young type designers to start the same way: first, learn religiously from the old fellows, then you can burn icons."

And on the future of the type design business: "One of my favorite quotes, from Maximilien Vox, says it all: 'There are too many typefaces and not enough typeface designers.' He wrote this before the age of computers, as if he predicted the tidal wave of typefaces we now must contend with."

Hand-lettered ITC Cerigo

ITC Ellipse

abcdefg
ghijklmn
opstuvw

Jean-Renaud Cuaz

Galena

The popularity of the roman character in Italian manuscripts was due to the revival of classical learning. Italy being the seat of the Renaissance, printing in roman types very naturally became the norm there earlier than in any other European country. John-Renaud Cuaz's Galena is a modern revival of these early fonts.

As in all other Oldstyle designs, the axis of curved strokes in Galena is inclined to the left, so that weight stress is at approximately eight and two o'clock. The contrast in character stroke weight is not dramatic, and hairlines are on the heavy side.

Several characteristics, however, distinguish Galena from other Oldstyle designs. The most obvious is its one-sided serif design. This is a trait of calligraphic lettering in which strokes are made quickly. The result is a spontaneous feeling to the design—and, perhaps, improved readability, since the serifs point in the direction that the eye travels across a page.

As for the name, *galena* is the Latin word for the common mineral lead sulfide, which occurs naturally in the form of lead-gray crystals. Galena is the principal ore in lead, the one-time basis for all metal type.

(gə lē'nə)

AgfaType Galena Italic

ABCDEFGHIJKLMNOPQRSTUVWXYZ
abcdefghijklmnopqrstuvwxyz
0123456789&@$%?!,;:.‹›''-()[]{}§†‡*

AgfaType Galena Bold

ABCDEFGHIJKLMNOPQRSTUVWXYZ
abcdefghijklmnopqrstuvwxyz
0123456789&@$%?!,;:.‹›''*-()[]{}§†‡

AgfaType Galena Bold Italic

ABCDEFGHIJKLMNOPQRSTUVWXYZ
abcdefghijklmnopqrstuvwxyz
0123456789&@$%?!,;:.‹›''*-()[]{}§†‡

AgfaType Galena Black

ABCDEFGHIJKLMNOPQRSTUVWXYZ
abcdefghijklmnopqrstuvwxyz
0123456789&@$%?!,;:.‹›''*-()[]{}§†‡

AgfaType Galena Black Italic

ABCDEFGHIJKLMNOPQRSTUVWXYZ
abcdefghijklmnopqrstuvwxyz
0123456789&@$%?!,;:.‹›''*-()[]{}§†‡

AgfaType Galena Small Caps

ABCDEFGHIJKLMNOPQRSTUVWXYZ
ABCDEFGHIJKLMNOPQRSTUVWXYZ
0123456789&@$%?!,;:.‹›''"*-()[]{}§†‡

AgfaType Galena Condensed

ABCDEFGHIJKLMNOPQRSTUVWXYZ
abcdefghijklmnopqrstuvwxyz
0123456789&@$%?!,;:.‹›''"*-()[]{}§†‡

AgfaType Galena

ABCDEFGHIJKLMNOPQRSTUVWXYZ
abcdefghijklmnopqrstuvwxyz
0123456789&@$%?!,;:.‹›''"*-()[]{}§†‡

AgfaType Galena Condensed Italic

ABCDEFGHIJKLMNOPQRSTUVWXYZ
abcdefghijklmnopqrstuvwxyz
0123456789&@$%?!,;:.‹›''"*-()[]{}§†‡

AgfaType Galena Condensed Bold

ABCDEFGHIJKLMNOPQRSTUVWXYZ
abcdefghijklmnopqrstuvwxyz
0123456789&@$%?!,;:.‹›''"*-()[]{}§†‡

Jean-Renaud Cuaz

ITC Cerigo

It is true that in a sense o
the afflictions which have
befallen us and observing
that no change of our con
dition could be expected j
that those prosperous day
were now past meskaz q

The first challenge Cuaz set for himself in creating ITC Cerigo was to create a type style that had the grace and elegance of Renaissance calligraphy. He met this challenge through the creation of a vertical italic type based on a fifteenth-century calligraphic hand.

Successfully meeting this challenge, however, presented Cuaz with yet another difficult design problem: how to draw a companion italic for the already cursive roman. Cuaz decided that since his roman was based on the writing style of the fifteenth century, the natural foundation for the italic would be the faster italic hand of the sixteenth century. The result is a controlled roman and a spontaneous italic that are both perfectly complementary cursive designs.

ITC Cerigo Book
ITC Cerigo Book Italic
ITC Cerigo Book Oblique

If you make an italic font vertical, it could look interesting, but the oblique serifs become inappropriate. The font loses the balance that the verticality calls.

ITC Cerigo, designed as a vertical italic, avoids this inconvenience by having nearly horizontal serifs. The result is a stabilized calligraphic design with an unusual reading comfort.

To create a good contrast between the roman and an italic companion, variations in thick and thin strokes were not sufficiant. The structure of the italic had to suggest a more rapid writing as a real italic should. If you make ITC Cerigo Book "oblique" as the computer can, you obtain a real italic because of the structure of the face. But the contrast with the roman is less important than the designed italic can offer.

If an italic word or sentence takes place inside a text set in roman, ITC Cerigo Italic should be used. If the italic is used alone, the possibility to electronically slant the roman gives the designer a new choice.

Test outputs of ITC Cerigo

ABCDEFGH
IJKLMNOPQRSTUVWXYZ
ÆŒ&ÇØ
abcdefghijklmnopqrstuvwxyz
æœfffiflffifflßçø
1234567890123456789o$$£¢¥
«(.,:;'?¿!i†["§"]‡%*/––)»

First versions of ITC Cerigo
and ITC Cerigo italic

Notebook page of ITC Cerigo

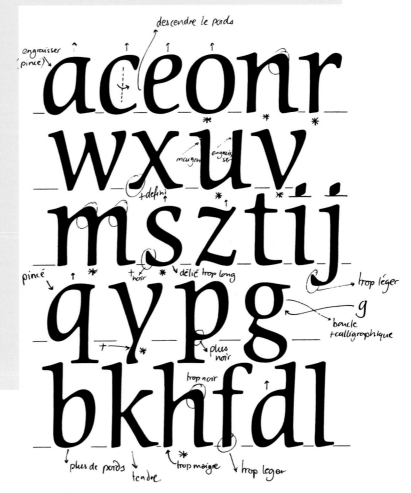

Scripts

Perhaps the most expressive of all letter styles, scripts reflect the mood of their writer, the sense of the time in which they are written, and the tools that were used to create them. The rotund strength of the Irish minuscule is very different from the verve and passion found in a sixteenth-century Spanish writing manual, and both of these are distinct from the scripts of the eighteenth-century Italian writing masters, with their strong lateral flow.

Scripts can be elegant and formal or spontaneous and funky. They can appear to have been drawn by quill pen, flat-tipped brush, crayon, or felt-tip marker. While scripts often defy classification and cannot be put into any neat system of typographic order, they can be classified into three loose categories: calligraphic, English roundhand, and brush.

Calligraphic

When Aldus Manutius commissioned Francesco Griffo to design the first italics at the end of the fifteenth century, he asked the designer to base his work on a popular calligraphic writing style of the time.

Griffo's italic evolved from a writing style popular among the educated; its heritage can be traced back to an early fifteenth-century scholar. By mid-century other scholars began to imitate his writing style, and by the late 1400s italic became the official writing style of professional scribes and the learned of southern Italy.

Cerigo Shelley

English Roundhand

Where calligraphic scripts tend to suggest a flat-tipped writing instrument, roundhand forms are influenced by a more flexible steel-point pen. This writing instrument can be pushed as well as pulled, which means that varying the pressure, rather than the angle of the nib, produces thick and thin strokes.

George Brickman's *The Universal Penman*, published around 1740, is generally considered the quintessential source of roundhand script designs. Within its pages appears a script that became the model for most other scripts now categorized as English roundhand.

Through the influence of scores of copy books published after *The Universal Penman*, the roundhand style of script writing spread throughout the western world. By the mid-1800s, it became the standard for penmanship taught to children in school. The American Palmer method, for example, is based on Brickman's scripts.

Matthew Carter's Snell Roundhand is arguably the most beautiful example of script made into type. Others such faces include Balmoral, Shelley (also drawn by Carter), Berthold's Englische Schreibschrift, and ITC Isadora.

Brush Scripts

Answering the needs of twentieth-century advertisers, Brush scripts are the hucksters of script types. In the early part of this century advertising agencies frequently employed lettering artists to hand-letter headlines as an alternative to typeset copy. In an effort to create unique and noticeable designs, art directors requested lettering that could not be duplicated in typeset form. Casual, quickly drawn brush scripts became the order of the day.

In the attempt to stay current with graphic trends, small printers who lacked dedicated lettering artists of their own began to request clones of those casual brush scripts in metal type. Responding to these requests was much easier than attempting to develop delicate connecting scripts, so many of these simpler brush scripts found their way into metal type. Kaufmann and Brush Script are two early brush scripts that are still with us today.

Script *Brush Script*

Dave Farey

hamburgefonts
hamburgefonts
hamburgefonts

ITC Highlander samples

"I'm a craftsman and not an innovator," claims David Farey. "I need a vehicle to be able to express my interpretation of a typeface." While no one would dispute Farey's ability as a type designer, it is true that his best and most successful typefaces are based on the work of others.

Farey gained his training in typeface design much as a craftsperson would: as an apprentice to an accomplished artisan. After high school, Farey worked for Letraset in the Fleet Street district of London. "The studio manager set me the task of retouching negatives of the artwork masters for the then tiny Letraset range, along with processing film, cleaning stencils, and making the tea. Although not quite an apprentice, I was sent on day release to the London School of Printing, where I attained my Intermediate City and Guilds certificate in photolithography and platemaking. But it was the lettering classes I enjoyed." Three years later, when Gary Gillot joined Letraset as the type studio manager, Farey says, "I was first in line to be trained by him as a stencil cutter."

Continuing a Lost Art

Farey is one of the very few type designers who, if given a sheet of photo-masking film and a stencil-cutting knife, can cut an absolutely perfect letter. "My last public appearance performing as a stencil cutter," says Farey, "was at ATypI in San Francisco in 1994. I enjoyed cutting a variety of ampersands, which is one of the most beautiful shapes within an alphabet, and almost a stencil-cutter's holiday. On the last day, after completing a Caslon Italic ampersand, which takes about ten minutes, I relaxed and reached for my coffee cup on the corner of my desk, which, to my surprise, contained a collection of small change."

Though a relatively small man, Farey is a giant as far as creative energy and enthusiasm for his work are concerned. He has designed hundreds of typefaces, created dozens of corporate alphabet designs, and drawn logos for countless magazines, retail products, and movie titles.

Design Tools

Farey says, "The first application I use for designing a typeface is pencil and paper. In terms of programs, to create a digital font, I use Ikarus for new designs, particularly if it's a commission for a magazine or newspaper. I use Macromedia Fontographer to modify existing designs." Over the years, Farey has grown comfortable working with Ikarus software, and he finds Fontographer drawings difficult to scale.

ITC Golden Cockerel initials

Cachet Book specimen

ABCDEFGHIJK
LMNOPQRSTU
VWXYZ&
abcdefghijklmn
opqrstuvwxyz

Broadcast

Farey says that most of his work falls into two categories: commissions and commercial fonts. "Commissions," he says, "are all about compromise and using your experience to come up with a suitable answer for the design problem. But the breadth of work is enormous, from a corporate alphabet that may need to last for five to ten years to film titles that will be used only once—but still be seen in ten years."

Commercial fonts, Farey says, are entirely different. "That's the opportunity to be creative on your own." But even here he imposes restraints on his designs. "I'm very conscious of type being fit for a purpose, and I build in legibility factors in all my designs. It's important to me that my typefaces can be read."

Farey says that the design process for him starts with "some nicely formed letters set in a word." He then expands on these initial designs until most of the capital and lowercase letters are rendered. Farey then goes back over these letters to insure that they are compatible with each other. "It's always a surprise," he says, "to check the first drawings against the finished versions. Often the letters that were inspirational to the design have changed and become subservient to the rest of their companions."

The Non-Letters Part of Typeface Design

Farey spends a great deal of time refining the spacing of his typeface designs. "I've threw out a complete lowercase italic when I found that they could not be spaced properly," he says.

To aspiring typeface designers, Farey offers the following observations: "There are two abilities required to become an established or recognized typeface designer. The first is application, or stamina. It's slow, grinding work to solve the incidentals and foreign sorts for a type font. The other is talent. There are, perhaps, many talented designers who do not have the stamina, and many mediocre designers who turn out fonts with 256 characters in 144 different weights and versions—and are still boring alphabets."

THE EUROPEAN

Dave Farey

Stellar

Stellar is a revival of Robert Hunter Middleton's original design for the Ludlow Typograph Company that began in the late 1920s. At the time, Middleton was asked to create a sans serif type family to compete with European Futura and Kabel fonts. Stellar was Middleton's attempt to raise the ante. Unfortunately, Middleton's employers were more interested in just cloning the competition. Stellar was shelved and Middleton drew Tempo, a face much closer in design to the competition.

Regarding his revival of Middleton's work, Farey says, "To me, Stellar was the classic example of a simplified roman, dignified and refined in sans serif form; particularly the lowercase, which although beautiful needed the most modification for today's standards. The x-height, diagonal terminals, and the width of letters needed a lot more discipline to balance as a unit—but Middleton's still in there!"

Farey's revival of Stellar is twice as large the original font family, ranging from the very light Stellar Nova to the very bold Zeta. In between are Delta and Epsilon. Farey says that "There needs to be a balance or choice between geometric sans serifs, such as Futura, and the industrial sans serifs such as Helvetica—it's time for Stellar to make a new appearance."

Nova
Delta
Epsilon
Zeta

Stellar family

Stellar Nova specimen

A B C D E F G H I J K L M
N O P Q R S T U V W X Y Z

Futura
Stellar
Helvetica

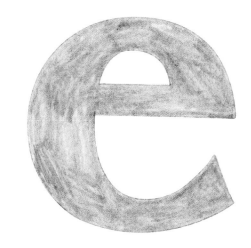

Stellar developmental drawings

Dave Farey

designer must care gift and s
perfect integration of design
typograpy. It may require the
unusual sizes, weights and p
ce, flops a.

ITC Highlander experimental swash letters

ITC Highlander

The creation of ITC Highlander stemmed from Farey's desire "to create a type family that was fresh and stood out from the crowd of other designs. At the same time, I did not want to create a design that was so distinctive, or so unusual, that it limited itself to just a few display applications." Adding to the challenge, Farey needed an existing design to base his new type family on. Farey used a design by early twentieth-century American lettering artist Ozwald Cooper as the basis for his own prototype font.

Farey calls ITC Highlander a soft-terminal monoline and feels that these soft terminals make the design more readable than most sans serif typefaces. Another aspect of the design that aids readability is the slightly uneven stroke weights. Farey choose to maintain this hand-drawn aspect of Cooper's original design. As a result, each weight of ITC Highlander was created by hand. This subtle deviation from perfection helps overcome the visual monotony common to many sans serif faces.

E
r
w
ıa
ge.
uf deren ve
erkennen

ß die Etru.
habete" 6
Chr. ¡Von
en; das fri
(Unterlauf) der †Albegna? E
geschnitztes (Elfenbeintäfelc
Zentimeter, auf dessen vertie
[Reste] zu erkennen sind. Au

ITC Highlander text sample

A Typographic Fairy Tale

Typographic history would have us believe that italic types were invented as a space-saving device by Aldus Manutius in the fourteenth century. It is said that Aldus's goal was to cut paper costs and thus make his publications less expensive. These inexpensive books would be available to those who previously could not afford books. The reality was then, as it is now, paper was expensive, but saving paper was not Aldus's goal in creating italic type—and Aldus never sold an inexpensive book.

Early sixteenth-century printers spoke of writing a typeset page as if it were a letter to a friend. As this unusual terminology implies, the typeface provided a much closer link between printer and reader than it does today. Certain styles of type were reserved for specific groups of readers. Rather than trying to save space with the development of his italic, Aldus was appealing to the educated, worldly, and wealthy readers of the early Italian Renaissance.

The heritage of italic type can be traced back to Niccolo Niccoli, an Italian scholar of the early fifteenth century. Niccoli started to oblique and add flourishes to his letters when he wished to write in a faster, more relaxed fashion. By the middle of the century other scholars began to imitate his writing style, and by the late 1400s italic became the official writing style of the learned.

The Typeface Design Business

Cursive writing had been developed by the same scholars and learned government officials for whom Aldus created his books. In adapting the style to print, he and Francesco Griffo were making books more appealing to their intended audience. Today, we would call this concept creative marketing.

Aldus's idea proved very successful—so successful, in fact, that other printers felt obliged to produce their own books in this new type style. The problem was that Aldus knew added value when he saw it, and was not about to sell fonts of his new invention to the competition. So the early printers did what has become a tradition in the history of type design—they copied the designs they could not buy. Not wishing to call attention to the plagiarism, but still needing to give the new style a name, they chose italic, after Italy, the country in which Aldus worked.

italics

a letter to a friend

Tobias Frere-Jones

Raised in a family of writers and printers, Tobias Frere-Jones learned the power of written text and naturally slipped into the design of letterforms. By age sixteen he had filled hundreds of notebook pages with sketches of letterforms and preliminary typeface designs, and designed his first typeface, which won a prize for best-of-category in The Type Shop of New York's Alphabet Design Contest. When he entered the Rhode Island School of Design, type and letterform design had displaced most of his other artistic interests. In his senior year at RISD, Frere-Jones split his time between working in Boston at The Font Bureau, where he developed full character sets for original typeface designs by Neville Brody, and working in Providence on his thesis, which was a series of experimental typefaces, "trains of thought I had been working on for a couple of years." After graduating in 1992, Frere-Jones began working full-time for The Font Bureau, where he is currently a senior designer.

In addition to teaching a class at the Yale School of Design, Frere-Jones has also lectured at the Pratt Institute, the Royal College of Art, and RISD.

A Different Kind of Type Designer
Frere-Jones is a different kind of type designer: his typefaces speak for themselves and defy pigeonholing. His work includes 1950s and 1960s revivals like Stereo, faces like Pilsner that would be perfectly at home in a turn-of-the-century Berthold type specimen book, alternative designs like Rietveld and Reactor, what he calls "blue-collar" designs like Garage Gothic, and traditional and graceful typefaces

Garage Gothic and Cassandra compariso

garage gothic

like his revival of Reiner Script.

Frere-Jones prefers to work with version 3.5 of Macromedia Fontographer. While other type designers often prefer to begin their designs in Adobe Illustrator, Frere-Jones says that he likes the ability to see his completed letters immediately combined into words that Fontographer offers. "This has been particularly helpful with many projects," he stated. "Determining the spacing for the caps or lowercase can be especially difficult, and Fontographer enables me to do virtually on-the-fly fine tuning of the letter spacing."

Frere-Jones is a tough critic of his own work and never releases any typeface that he believes will not have widespread applicability. Nor does he hold himself to a dry, utilitarian design philosophy: "I try to keep myself interested and amused," he explains. "What often wins out over any concern is drawing what I'm interested in drawing, because I enjoy it, not because I am going to save the world of typography."

sandra

HALOGEN LIGHTS
BOLD

A new antifreeze with a cool, minty flavor!
REGULAR

Buckets full of nuts and bolts
BOLD

MONKEY WRENCH
BLACK

PROFESSIONAL & RELIABLE
BOLD

MERCANTILE
REGULAR

Garage Gothic specimen © The Font Bureau Inc.

Mashed Potatoes
LIGHT

Board meeting erupts in a food fight worthy of any sixth-grade lunchroom
BOLD

LUNCHTIME FIGHT
BLACK

Cafeteria specimen © The Font Bureau Inc.

Interstate™

TYPEFACES

Interstate, one of Frere-Jones' commercially successful typefaces, is based on the typeface used on interstate highway signage, and was designed using the original sign manual sketches and kerning tables published by the United States government.

Classified as a late nineteenth-century grotesque, Interstate shares its basic proportions and attributes with faces like Helvetica and Univers, but that's where the similarity ends.

Interstate's terminals of ascending strokes are cut at an angle to the stroke, and terminals of curved strokes are cut at a ninety-degree angle to the stroke rather than parallel to the baseline. "The oblique terminals make the counterforms more open—thus performing better at smaller sizes and on rough paper stocks. The dynamic of each character, rather than pointing back at itself (as it would in Univers or Helvetica) points at its neighbors. The characters thus bind themselves more readily into coherent and readable word-shapes," says Frere-Jones.

Sign using Interstate PI

Helvetica
Interstate
Univers

INTERSTATE

TRAFFIC VIOLATIONS
BOLD
State trooper did not take kindly to my interpretive driving style
LIGHT CONDENSED

FAST LANE
BOLD CONDENSED
Rush hour drivers become more and more frantic
REGULAR CONDENSED

CONSTRUCTION AHEAD
BLACK
ROADS ARE TORN UP & PLOWED UNDER
BOLD COMPRESSED
Work crews play catch with gobs of hot asphalt
BOLD

Southbound Traffic
LIGHT COMPRESSED
Full of honking, yelling and shouting
LIGHT
DECREPIT MUFFLER IN TOW
BLACK CONDENSED
I made a quick visit to the drive-thru psychotherapist
REGULAR
THE THERAPIST TOLD ME THAT I SUFFER FROM AN OEDIPAL STICK SHIFT
BLACK
A trail of sparks followed me down the road
BOLD CONDENSED
Commuter War Stories
BLACK COMPRESSED
IN RAGE AND FRUSTRATION, I THREW MY KEYS INTO THE RIVER
LIGHT
THEN I NOTICED I WAS MILES FROM HOME
REGULAR COMPRESSED

Light, Light Condensed, Light Compressed, Regular, Regular Condensed, Regular Compressed, Bold, Bold Condensed, Bold Compressed, Black, Black Condensed, Black Compressed

ABCDEFGHIJKLMNOPQRSTUVWXYZabcdefghijklmnopqrstuvwxyzßfifl
¶$§£¥#ƒ0123456789%‰¢º=<+>'"¿?¡!&(/)[\]{|}*.,:;...«»‹›""''·,,_·†‡@®©™√
áàâäãåæçéèêëíìîïñóòôöõøœúùûüÿıÁÀÂÄÃÅÆÇÉÈÊËÍÌÎÏÑÓÒÔÖÕØŒÚÙÛÜŸ

61 special characters: ɑ←→↑↓↕✛

Interstate specimen © The Font Bureau Inc.

INTERSTATE

Light Grumpy wizards make toxic brew for the evil queen and jack. Lazy movers quit har ard packing of papier-mâché jewelry boxes. Hark! 4,973 toxic jungle water vipers quietly drop on zebras for meals! New farm hand (picking just six quinces) proves strong but laz Back in my quaint garden: jaunty zinnias vie with flaunting phlox. Waltz, nymph, for quic jigs vex Bud. For only $65, jolly housewives made "inexpensive" meals using quick-froze

Regular Grumpy wizards make toxic brew for the evil queen and jack. Lazy movers qu uit hard packing of papier-mâché jewelry boxes. Hark! 4,973 toxic jungle water vipers quietly drop on zebras for meals! New farm hand (picking just six quinces) proves str ong but lazy. Back in my quaint garden: jaunty zinnias vie with flaunting phlox. Waltz, nymph, for quick jigs vex Bud. For only $65, jolly housewives made "inexpensive" me

Bold Grumpy wizards make toxic brew for the evil queen and jack. Lazy movers qui hard packing of papier-mâché jewelry boxes. Hark! 4,973 toxic jungle water vipers quietly drop on zebras for metals! New farm hand (picking just six quinces) proves strong but lazy. Back in my quaint garden: jaunty zinnias vie with flaunting phlox. Waltz, nymph, for quick jigs vex Bud. For only $65, jolly housewives made "inexpen

Black Grumpy wizards make toxic brew for the evil queen and jack. Lazy movers quit hard packing of papier-mâché jewelry boxes. Hark! 4,973 toxic jungle water vipers quietly drop on zebras for meals! New farm hand (picking just six quinces) proves strong but lazy. Back in my quaint garden: jaunty zinnias vie with flaunti phlox. Waltz, nymph, for quick jigs vex Bud. For only $65, jolly housewives made

Light Condensed Grumpy wizards make toxic brew for the evil queen and jack. Lazy movers quit hard packing of papier-mâché jewelry boxes. Hark! 4,973 toxic jungle water vipers quietly drop on zebras for meals! New far farm hand (picking just six quinces) proves strong but lazy. Back in my quaint garden: jaunty zinnias vie with fl flaunting phlox. Waltz, nymph, for quick jigs vex Bud. For only $65, jolly housewives made "inexpensive" meals using quick-frozen vegetables. Sixty zippers were quickly picked from the woven jute bag. Jaded zombies acte

Regular Condensed Grumpy wizards make toxic brew for the evil queen and jack. Lazy movers quit hard pac king of papier-mâché jewelry boxes. Hark! 4,973 toxic jungle water vipers quietly drop on zebras for meals! New farm hand (picking just six quinces) proves strong but lazy. Back in my quaint garden: jaunty zinnias vi with flaunting phlox. Waltz, nymph, for quick jigs vex Bud. For only $65, jolly housewives made "inexpensiv meals using quick-frozen vegetables. Sixty zippers were quickly picked from the woven jute bag. Jaded zon

Bold Condensed Grumpy wizards make toxic brew for the evil queen and jack. Lazy movers quit hard pa acking of papier-mâché jewelry boxes. Hark! 4,973 toxic jungle water vipers quietly drop on zebras for meals! New farm hand (picking just six quinces) proves strong but lazy. Back in my quaint garden: jaun ty zinnias vie with flaunting phlox. Waltz, nymph, for quick jigs vex Bud. For only $65, jolly housewives made "inexpensive" meals using quick-frozen vegetables. Sixty zippers were quickly picked from the w

Black Condensed Grumpy wizards make toxic brew for the evil queen and jack. Lazy movers quit hard packing of papier-mâché jewelry boxes. Hark! 4,973 toxic jungle water vipers quietly drop on zebras for meals! New farm hand (picking just six quinces) proves strong but lazy. Back in my quaint garden jaunty zinnias vie with flaunting phlox. Waltz, nymph, for quick jigs vex Bud. For only $65, jolly hous sewives made "inexpensive" meals using quick-frozen vegetables. Sixty zippers were quickly picked

Familiarity is the foundation of legibility, lending this sanserif a strong edge as one of the most legible faces. Interstate is based on the signage alphabets of the United States Federal Highway Administration, alphabets that we read every day as we drive. Tobias Frere-Jones designed Interstate in 1993, and in 1994 expanded it for the Font Bureau to full character sets in a full set of weights, prepared for both text and display; FB 1993-

62

Interstate text samples

Signs using Interstate PI

Tobias Frere-Jones

Pilsner

Pilsner Regular

ODG

Pilsner was inspired by a French beer label that was set in a hand-drawn blackletter type, but simplified for a non-German market. Frere-Jones says, "I forgot to peel off the label and take it with me. What I started Pilsner from, then, was a memory of the general atmosphere of the beer label, rather than any of its specific letterforms."

Pilsner is a sans serif design that, in a world of gargantuan x-heights, is refreshingly diminutive. Frere-Jones says, "The extremely small x-height made the relationship of the caps to the lowercase very difficult. In the end, the solution was to make the caps considerably lower than the lowercase ascenders. If they had been drawn to the same height, the caps would overpower the lowercase." Pilsner has no curved strokes; all letters are made up of straight lines. Even normally round letters like the "O," "D," or "G" are constructed of short, angled strokes. According to Frere-Jones, "While not unique, it's rare to find a typeface that's drawn with that constraint."

Pilsner is a display font that meets the criteria for successful display typeface designs: it's versatile, yet distinctive and will be around—and used—for a long time.

BEER

Pilsner Black

ab
jk
rst

OLD KITCHEN
BOLD

The offices of Grate, Peel, Squeeze & Bake
REGULAR

NEW CULINARY LAW FIRM
BLACK

Handling cases in wrongful stir fry, negligent marinade, baker's comp
LIGHT

Your claims rise like yeast!
REGULAR

Pinch of Salt
BOLD

CASE SETTLED OUT OF COURT
LIGHT

For an undisclosed amount of nutmeg and cilantro
REGULAR

Courtroom
BLACK

Deposition with secret pesto sauce
BOLD

WINNINGS WILL GO TO CHARITIES FOR THE PECKISH AND SNACK-PRONE
LIGHT

CONSORTIUM OF WORTHY CAUSES
REGULAR

34 Donations
LIGHT

FUND RAISING GALA
BLACK

Pilsner specimen © The Font Bureau Inc.

d e f g h i

m n o p q

v w x y z

Type Sizes

When punch cutters created fonts of metal type, each size of a given typeface was usually slightly different in design and proportion from the next size up or down. When comparing the design and proportions of fonts at extreme ends of the size spectrum, the differences could be dramatic.

Typography is a visual medium, so readability is paramount. In a serif typeface, for example, the thin parts of a character were traditionally designed proportionally heavier for small sizes than for large sizes. If they were left the same weight as in the larger sizes, the contrast between thick and thin would be too great, making copy difficult to read. The interior spaces of characters were usually more open, and the lowercase characters were proportionally larger in small sizes of type than in large sizes—again to improve the readability of the font.

readability

readability

Adobe Jenson at 72 point in both the 72 point optical size (top)
and 8 point optical size (bottom).

JONATHAN HOEFLER

Hoefler Text family

Jonathan Hoefler's New York studio, the Hoefler Type Foundry, specializes in the design of custom and original typefaces. In fact, Hoefler's was the first digital foundry dedicated to custom typeface design and has begun to license his fonts for general use.

In a time when grunge type and alternative typeface designs seem to be the norm, Hoefler's type designs are graceful and thoroughly rooted in typographic heritage. Even his experimental types—Fetish, Gestalt, and Enigma—reveal his solid understanding of the proportions and rhythms of the Latin alphabet. Hoefler sees his work as an investigation into the circumstances behind historical forms. Each of his designs attempts to interpret the critical and aesthetic theories that precipitated a particular style of lettering. Hoefler says the antique type specimen books he collects provide additional inspiration for his interpretations.

A scholar, but not an academic, Hoefler abandoned art school in his first year and went to work for Roger Black's studio in New York. There, Hoefler learned the difference between completing a class assignment and solving a client's real-world design issues. Today, after seven years of professional work, Hoefler has created hundreds of type designs and several dozen type families. To see Hoefler's work, one need only go to the nearest magazine stand and pick up an issue of *Rolling Stone*, *Harper's Bazaar*, the *New*

Hoefler Text Expert Roman

HOEFLER TEXT EXPERT ROMAN

T. S. ELIOT

AUCTION TODAY

MOZART'S SYMPHONY

ALGONQUIN ROUND TABLE

NEW COLISEUM ARCHITECTURE

AN EXHIBIT OF THE WORKS OF MALEVICH

Hoefler Type Foundry packaging

York Times, *Sports Illustrated*, or *House & Garden*.

In seemingly constant design mode, Hoefler continually doodles characters—on napkins, pieces of notepaper, and any thing else that is handy. With the nucleus of a design on paper, Hoefler moves to Adobe Illustrator, where all of his first electronic drawings begin. Hoefler then moves the electronic files to Macromedia Fontographer, which he calls a "necessary evil." He prefers the older 3.5.1 version because it is faster, more intuitive, "and just plain better."

Although he could take advantage of Fontographer's default baseline, x-height, cap height, ascender, and descender lines, Hoefler uses virtually the same method as Ed Benguiat (who still designs type sans computer) to establish character design parameters. He stashes a batch of finished characters on the edge of the screen and uses these as patterns to check the new designs he creates.

Traditional typeface design (for metal-type fonts) usually begins with the letters "H," "O," "n," and "o." Hoefler then adds "D" and "p" because they are, in his words, "half-round characters that help determine character spacing." With this foundation, the cap height, the x-height, the widths of both cap and lowercase curved and straight strokes, cap and lowercase

proportional widths, and the basic spacing of the font are established.

When he completes the Illustrator letters, Hoefler draws a line above and below each character at the top and bottom boundaries of the em square, copies the lines and letters to the clipboard, and pastes them into Fontographer. This process ensures that the characters retain their proportions during the cut-and-paste procedure.

Much of Hoefler's work is on custom typeface designs for corporations and publications. His lengthy client list includes such notables as Apple Computer, *Worth* magazine, the *Boston Globe* newspaper, IBM, Sony Music, and *Us* magazine. In 1991, Hoefler founded the Hoefler Type Foundry, Inc. to distribute his typefaces to art directors and graphic designers.

Specimen page
composed in Didot

Six faces for Sports Illustrated

BEHOLD
S. I. FEATHERWEIGHT
SIX EXCITING NEW
S. I. LIGHTWEIGHT
FACES
S. I. HEAVYWEIGHT
DEVELOPED ESPECIALLY
S. I. MIDDLEWEIGHT
FOR SPORTS
S. I. WELTERWEIGHT
ILLUSTRATED
S. I. BANTAMWEIGHT

HTF FETISH № 338

HTF FETISH № 338

Lengthy rodomontade TK.

ION
FETISH
EXCESSIVE?
CALL IT VINTAGE
AN AIR OF REFINEMENT
A FONT OF HERITAGE AND BREEDING
SERVICEABLE FOR ALL PURPOSES GREAT OR SMALL
USE WHEREVER LUSH AND ROMANTIC CONNOTATIONS ARE CALLED FOR
BUT NOT AN IDEAL CHOICE FOR USE IN TELEPHONE DIRECTORIES OR FOR DRUG INTERACTION WARNINGS

ABCDEFGHIJKLMNOPQRSTUVWXYZ1234567890

FET

HTF Fetish™ No. 338 comments on the mythopoetic notion of 'classicism' which figures so prominently in all levels of graphic design in America. It parodies the notions of 'fanciness'

ISH

in which not only designers but the lay public participate; its forms are as welcome in the pages of *Rolling Stone* as in the menu of *Ye Olde Coffee Shoppe*. While it quotes

{ No. }

freely from a formal vocabulary of disparate historical styles (such as the Gothic, Victorian, Byzantine, Celtic and Moorish), it is ultimately an invention, one which is endemic

338

only to a vague, romantic heritage to which no American truly belongs, but to which many aspire. Like all HTF fonts, Fetish has a complete character set and kerning tables.

Fetish sample

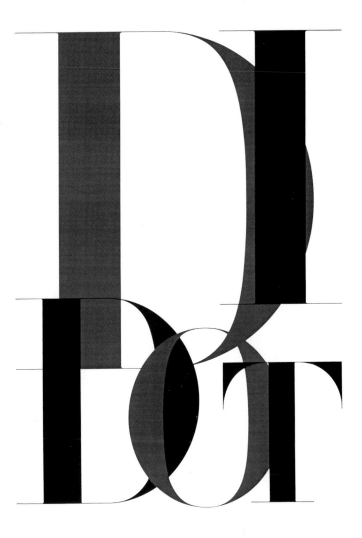

Didot sample

ABCDEFGHIJ KLMNOPQ RSTUVWXYZ

GRAZIA BODONI

1234567890

Grazia Bodoni sample

Jonathan Hoefler

TYPEFACES

Ziggurat *(and its siblings)*

Ziggurat was commissioned by *Rolling Stone* magazine in 1991. Originally intended as a one-style display family, it grew into an extended type family of four designs: Ziggurat, Leviathan, Saracen, and Acropolis —collectively called the Proteus Project.

Maintained in Ziggurat are the explicit qualities of the Egyptian types: the dramatic distinction between thick and thin strokes, the overwhelmingly bold capitals, and the dramatic play of negative space within the letters. Hoefler says, "It is intended that Ziggurat, even where it departs from the historic path, provides a record of this structuralist approach to designing type." Ziggurat was first shown in *Rolling Stone* magazine in 1991.

Two years later, the magazine's impending shift to electronic publishing presented an ideal opportunity to create a new and flexible format in which the magazine's basic typography could be altered for every issue. This is where Hoefler reentered the picture. He was asked to extend the Ziggurat family with new designs that could be interchangeable with the parent face and yet present a totally different typographic look.

Leviathan, the first of the new additions, is a variation of the original Ziggurat design, but it is a sans serif style. Following Leviathan was Acropolis, a typeface reminiscent of the Grecian style that flourished in American and English in the late 1830s. Acropolis is unique in that its italic is of a distinctly ahistorical design. Unlike the Egyptians and Gothics upon which Ziggurat and Leviathan are based, none of the Grecian faces were made as either metal or wood fonts. None of them were conceived with italic fonts. Acropolis is a Hoefler experiment in historical invention. The last of the new additions was Saracen, a design with the addition of triangular Latin serifs.

These designs are informed by nineteenth century type, designed foremost for use on posters and in handbills.

SANS SERIF *or* GOTHIC

Competition for attention in the urban enviroment led printers to embrace these bold and shocking forms.

CHAMFERED *or* GRECIAN

The names of these styles were drawn from the faddish fascination with antiquity, reflected too in these faces.

WEDGE SERIF *or* LATIN

Alt Sail Malt Carrie Elysian Tangency

144 POINT
120 POINT
96 POINT
72 POINT
60 POINT
48 POINT
42 POINT

Saracen specimen

HTF ZIGGURAT™ TWO FONTS

ZIGGURAT BLACK | ZIGGURAT BLACK ITALIC

see also
THE PROTEUS PROJECT p.
SARACEN p.
ACROPOLIS p.
LEVIATHAN p.

Originally developed for ROLLING STONE, *Ziggurat is a typeface in the "egyptian" idiom, a style of slab serif introduced to printing types around 1815*

An exhibit of Industry shall be Mounted next month in the Offices of

The new State Lottery begs leave to submit an Advertisement of offer

Modern Technique used in the Making of Consumer Items

Relax Comfortably with Rake's Patent Magneto Unguents

Informational Advantageous

Congressional Subcommittee

Marginals

Sforzando

Regiment
Speaker
Loga
Pan
EN

R R R R
ziggurat · saracen · acropolis · leviathan

A typographic theme and variations first designed for *Rolling Stone* consists of four sub-families, each in a different nineteenth century *egyptian*, a sans serif *gothic*, a wedge serifed *latin*, and a ... share a common set of character widths, they are largely i...

HTF SARACEN™

SARACEN BLACK

see also
THE PROTEUS PROJECT p.
ZIGGURAT p.
ACROPOLIS p.
LEVIATHAN p.

Originally developed for ROLLING STONE, *Saracen is a variation on the Ziggurat typeface in the nineteenth-century "latin" style.*

Groton Conventioneer Notes Unusual Arrival of Classic Submarines

Specialization of Industrial Work

Middle School Examinations

Marigold

TARGET
REIMS
LIME
MISER
TIES

R R R R
ziggurat · saracen · acropolis · leviathan

The Industrial Revolution was a valuable incubator for typographic oddities, many of which were essentially variations on the theme of the slab-serif (or *egyptian*). It is odd that the same 19th century typographers who sought the extreme, creating both compressed and expanded designs, never made a wedge serif (or *latin*) of this rather obvious proportion.

HTF ACROPOLIS™ TWO FONTS

ACROPOLIS BLACK | ACROPOLIS BLACK ITALIC

see also
THE PROTEUS PROJECT p.
ZIGGURAT p.
SARACEN p.
LEVIATHAN p.

Originally developed for ROLLING STONE, *Acropolis is a "grecian" typeface, a style popularized by 19th century American wood type manufacturers.*

Archaeological Survey in Herculaneum tells a Terrifying Tale of Woe

Somewhere in the Dell is Buried the Treasure Immeasurably Worthy

Our Hero, last Seen Replacing the Grail Below The Pilaster

Seen Here Another Great Grotesquerie of the Mesozoic era

Anachronistic Cursive Types

Unexpurgated Four Quartets

Malaysian

Taxpayers

Maquette
Sampled
Magic
Ideal
EN

R R R R
ziggurat · saracen · acropolis · leviathan

Every historical revival involves creating things which the original source lacks. In the case of Acropolis, the nineteenth century *grecian* style has been outfitted with a crucial component which past typefounders neglected to provide: an italic. Lacking any historical precedent, this face attempts to be sympathetic to historical form while avoiding nostalgic clichés.

HTF LEVIATHAN™ TWO FONTS

LEVIATHAN BLACK | LEVIATHAN BLACK ITALIC

see also
THE PROTEUS PROJECT p.
ZIGGURAT p.
SARACEN p.
ACROPOLIS p.

Originally developed for ROLLING STONE, *Leviathan is a sans-serif variation on the Ziggurat typeface.*

Within the Boundaries of this Jurisdiction did our Suspect exhibit an

Stevedores Wanted! An Association of Shipping Magnates Requires the

Franco–Hungarian Industrial Concern Names new Officer

Submit drawings to Patent Department for Board Approval

Abbreviations Imperceptible

Also Known As Ziggurat Sans

Anecdotes

Horizontal

Maritime
Spartan
Ingots
Ends
ME

R R R R
ziggurat · saracen · acropolis · leviathan

The typographic term "gothic" reminds us that 19th century Englishmen were enthralled with antiquity, and that they saw in these sans serif types a primitive beauty—a sort of *Ur*-letter, as distant and exalted as the ancient world. It is remarkable that the sans serif went unexplored as a style for so long: the first sans serif type was introduced in 1815.

TYPEFACES

GESTALT

Designed in 1991, Gestalt is an experimental typeface. Its skeletal design was inspired by a tenet of Gestalt psychology, which suggests that no idea is comprehensible out of context. As a result, according to Hoefler, "every individual character in the Gestalt family is ambiguous."

An overhaul of the family in 1993 included the completion of the previously limited character set, replacement of the original old-style figures with lining ones, and the addition of the bold and outline weights. Gestalt Yin & Yang, a variation on the conceptual design of Gestalt Linear, exists as two fonts registered for use in two colors.

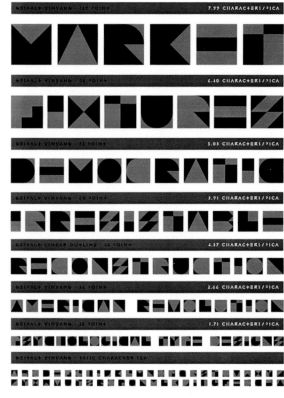

GESTALT YIN & YANG · *An Experimental Two-Color Design, 1993*

Gestalt Yin and Yang

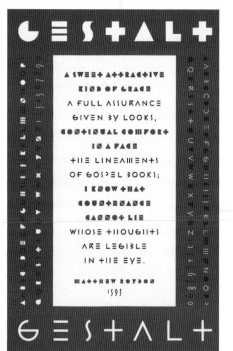

Gestalt Linear and Gestalt Volumetric

GESTALT OUTLINE

ER
BIO
RED
TYPE
REFLEX
POWERFUL
RESOLUTIONS
NDECOMPOSABLE
CHEMICAL REACTION
TECHNICAL DIFFICULTIES

HTF GESTALT BOLD

NE
TIC
UCT
FACE
DECADE
MYSTICAL
INTERFERON
RECONCILIATION
COMPLEX EQUATION
THE WORKS OF ERASMUS

80
60
48
36
24
18
16
11
9
7

Gestalt Outline and Bold specimens

ONE TENET OF GESTALT PSYCHOLOGY
STATES THAT NO IDEA IS
COMPREHENSIBLE OUT OF CONTEXT.
IT WAS THIS NOTION THAT
INSPIRED THE GESTALT FAMILY OF
TYPEFACES

Gestalt

Numbers

While our present letterforms evolved from the Roman monumental letters, the numerals we use have an Islamic origin. The numbering system used by the Romans was based on capital letters. While these worked well for monumental inscriptions, they easily become long strings of characters that are difficult to read and virtually impossible to use in any form of extended mathematical computation.

When the lowercase alphabet became standard in about 800 A.D., roman numerals also changed from the old capital form to lowercase designs. The good news was that roman numerals became compatible with the most commonly used letterforms; the bad news was that they were still of limited use.

The Romans Didn't Have All the Answers

While Greece and Rome may have been centers of learning for history and literature, the center for mathematical study was elsewhere. Early cultures searched for a numbering system that would work in a variety of situations, but the solution was hampered for centuries by the absence of the concept of zero. It wasn't until the sixth century A.D. that the idea of zero as a number was developed—in India, not Rome.

In their contact with India as traders, the peoples of the Arab world picked up the concept of zero and became sophisticated mathematicians in their own right. Commerce eventually forced the conversion from roman to arabic numbers as merchants found roman numerals too difficult to work with. It took many years, however, for the Western world to incorporate these characters into printing and writing. As late as the twelfth century, more than two-thirds of European numbers departed from the forms with which we are currently familiar.

I II III IV V VI VII VIII IX X

First Numbers as Type Design

Claude Garamond is credited with creating the first font of type with numbers designed to work with the letterforms of a specific typeface. Garamond intended his numbers to be set as part of text copy and designed them to have the same proportions as lowercase letters. Like lowercase letters, Garamond's numbers are based on three forms: ascending, medial, and descending. This lowercase style of numbers became a model for type designers until the late eighteenth century. It was then that a new kind of number (called ranging) was introduced for mathematical and technical typesetting. The idea was that the larger numbers would be a more legible alternative to Garamond's design. If the first numbers used in printing can be considered as lowercase characters, then ranging numbers should be thought of as uppercase designs. Ranging figures are also sometimes created with a common width so that columns of numerals will align. When this occurs they are called tabular numbers.

Looks Can Be Deceiving

At first glance, ranging numbers may appear to be more legible than Garamond-based numbers. Legibility studies have proven that this is not the case at all: lowercase numbers are moderately more legible than ranging numbers when isolated, and considerably more legible when set in groups.

For many years printers and typographers used both sets of numbers, but as machines began to be used for setting type, typographic variety was sacrificed for mechanical efficiency. Machine-set type had limited character sets that allowed for only one set of numbers. Generally, the lowercase design was used for book work, while the ranging design was relegated to commercial work. When phototype replaced machine-set metal type, most foundries chose the ranging style for inclusion in their fonts. To this day, traditionalists tend to refer to the style of numbers found in Garamond's font as old-style.

1234567890
1234567890

12
34
56
78
90

James Montalbano

James Montalbano saw his future in printing type, not designing it: he took every printing elective his high school offered. He graduated from college as an industrial education major with no idea that graphic design, let alone type design, even existed as a profession.

Post-college, Montalbano taught undergraduate courses in screen printing and offset lithography. "Half of my students were graphic design majors," recalls Montalbano. "It was here I finally found out about graphic design."

Back to School

Montalbano took independent study courses in graphic design, but he laments, "All the other design students must have been closet illustrators, because they all could draw and I could not." To compensate, Montalbano started emphasizing type in all his projects. "Type became a design medium, instead of a production tool."

Original drawings for ITC Nora

Enter Computer Technology

Over the next few years Montalbano worked as a magazine art director. "I was continually drawing alphabets in my free time," he says, "but I always ended up putting them away, because there was no viable way to convert my drawings into fonts."

The world changed for Montalbano when he bought his first Macintosh computer. "By using a software application called Ikarus M and interfacing with a digitizing tablet, instead of a scanner, I could work directly off of my drawings," he explains. Soon after, he started Terminal Design, a graphic and type design studio. When International Typeface Corp. released

his design of ITC Orbon, not only did font sales increase, Montalbano also began to receive private typeface commissions from magazines such as *Details*, *Vanity Fair*, *Sassy*, *GQ*, *Gourmet*, and *Glamour*.

An Educator's Advice

Asked for advice to those just starting out, Montalbano responds, "You have to fall in love with the letterforms. Find some faces that you like and really get to know them. Draw them, trace them, get to understand the optical illusions that typefaces contain. Look back at all the historical aspects of type and letter design. Also, you must study, and be aware of, the historical forms to be able to draw them well."

(left and above) Cover and interior page of *Condé Nast Sports for Women*, featuring Johan Gothic

TYPEFACES

1994
TDI Senza

1995
TDI Didot Display
TDI Progressive Psychosis 1
ITC Orbon

1996
ITC Freddo

1997
ITC Nora
ClearviewOne
Johan Gothic
VF Sans

NOT TO PERAMBULATE THE CORRIDORS DURING THE HOURS OF REPOSE IN THE BOOTS OF ASCENSION.

COPY TAKEN FROM A SIGN IN A AUSTRIAN SKI RESORT.

IT IS FORBIDDEN TO ENTER A WOMAN EVEN A FOREIGNER DRESSED AS A MAN.

COPY TAKEN FROM A SIGN IN A BANGKOK TEMPLE.

LADIES ARE REQUESTED NOT TO HAVE CHILDREN AT THE BAR.

COPY TAKEN FROM A SIGN IN A NORWEGIAN COCKTAIL LOUNGE.

VF Sans is an original sans serif design consisting of Light, **Roman**, SMALL CAPS and **Bold fonts**, created by Terminal Design, Inc. for Vanity Fair Magazine in 1997.

Terminal Design Inc.•212-691-1754

Tdf VF Sans
Light, **Roman**,
SMALL CAPS
& Bold

Precise Rendering Tools

Montalbano has assembled a relatively sophisticated computer system to create his typefaces. He has a Power Computing 132-MHZ Macintosh clone with 86 megabytes of RAM and a one-gigabit internal hard drive. Added to this are a 20" (51 cm) Radius color monitor, a CD-ROM drive, two external hard drives, and

(left and below)
Ikarus printouts of ITC Nora

Ikarus printouts of ITC Freddo

a bevy of Zip, Jaz, and SyQuest drives. He also uses a Umax 840 Scanner and a very large Aristo digitizing tablet as part of his design tools. He outputs work on a LaserMaster 1200 dpi laser printer.

"I like Ikarus M," Montalbano says, "because I can digitize directly from my artwork via an Aristo digitizing tablet: no scanning needed. I also like the precision of Ikarus—10,000 units to the em. Ikarus also is a very powerful interpolation tool. If you create your axis weights correctly, Ikarus also does an exceptional job of creating intermediate weights."

Even though he is surrounded by computer technology, Montalbano begins the typeface design with pencil and paper. He usually starts with the lowercase "n" and "o.""With them, you get a feel for what most of the lowercase letters will look like." When drawing the uppercase letters, Montalbano usually begin with "E" and "O." He draws the letters quite large: 40 inches (100 mm) for a capital letter, and sometimes larger. After he is satisfied with the initial drawings Montalbano digitizes the characters by hand, using Ikarus M.

(below) Clearview Regular,
graphics by Meehere Associates

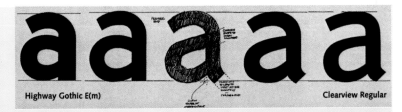

Highway Gothic E(m)

Clearview Regular

(right) ClearviewOne Highway, graphics by Meehere Associates

Highway Gothic Series E(m)*

Clearview 1:6.1 With less letter space improves word pattern recognition.

Clearview 1:6.1 Using same overall area as E(m), Clearview word is 112% larger, with considerable increase in legibility.

equal area

Highway Gothic Series E(m)*

6% reduction

Clearview 1:6.1 Letter spacing for conventional road guide signs

15% reduction

Clearview 1:6.1 Letter spacing for street name signs

James Montalbano

ITC Orbon

ITC Orbon Light, Regular, Bold, and Black (left to right)

Montalbano got the idea for ITC Orbon from black-letter calligraphy. He became intrigued with the condensed letterforms and modular character shapes. "Seeing all those letters being created out of four or five basic strokes prompted me to experiment with the same concept," recalls Montalbano. "I combined that idea with the notion of taking historical forms like German gothic blackletter and progressively paring them down to achieve a futuristic version—as if the old form naturally evolved over several hundred years to arrive at a postmodern incarnation." The character shapes of ITC Orbon grew out of these experiments.

The typeface was originally to be called Orblon because the letters are oblong and orb-like. The marketing people at International Typeface Corp., however, felt that name sounded too much like a synthetic fiber, so it was changed to Orbon.

Sorry Midgets will always be available tomorrow!

We take your bags and send them in all directions.

Teeth extracted by the latest Methodists.

Our wines will leave you nothing to hope for.

ITC Orbon™ Light, Regular, Bold & Black

ITC Orbon specimen

ITC Orbon Black

etter

Evolution of the Alphabet

The Roman capital letters grew out of the formal letterforms that were carved into monuments and buildings and used for important manuscripts. Though these letters were carved in stone, they reflect the same principles as handwritten letters. Modern typefaces are curved and have thick and thin graduations in stroke thickness because handwriting with flat pens shaped ancient letters this way.

The Roman capitals have had, and still have, the greatest influence on the design and use of capital letters. They have remained the classic standard of proportion and dignity for almost two thousand years.

Up till about 800 A.D. changes in the alphabet were gradual and evolutionary—there were no clear-cut lines of demarcation in design development. When Charlemagne became Holy Roman Emporer, he undertook the development of a consistent writing style. The Carolingian minuscule, as it came to be known, is the forerunner of modern small letters.

These two standards, the Roman capitals and the small letters that evolved from the Carolingian minuscules, were the basis for letterforms when movable type was invented by Johannes Gutenberg. As the Renaissance spread through southern Europe, Griffo, Jenson, and Garamond used these two models for their own typefaces in the fifteenth and sixteenth centuries. The standard was maintained in the eighteenth century in the work of John Baskerville, and it has continued well into the twentieth, with the type designs of Frederick Goudy, Hermann Zapf, and Matthew Carter. The standard also seems destined to continue in this function for some time to come. Although attempts have been made to tamper with letterform designs—to condense them or expand them, to equalize their varying widths, to electronically change their proportions—the results have not replaced the design standard set by the Romans and their successors. It has become the quintessential melding of art and information.

Au vāqarā e dua na ōtela sau māmada!

ABCDEFGHIJKLMNOPQR
STUVWXYZ abcdefghijklm
nopqrstuvwxyz1234567890

Showcard Moderne

DESIGNER

JIM PARKINSON

Jim Parkinson has worked as a lettering artist for over thirty-three years—twenty-five of those in Oakland, California. Prior to devoting much of his time to typeface design, Parkinson was a lettering artist and logo designer. His work has appeared in print advertising and on book jackets, packaging, album covers, posters, billboards, movie titles, and signage. Parkinson has designed logos for clients as diverse as the Ringling Bros. and Barnum & Bailey Circus and Specialized Bicycles. His publication logos include *Rolling Stone*, *Newsweek*, *Sierra*, and *Parenting* magazines, and the *Atlanta Journal* and *San Francisco Examiner* newspapers. He has also designed several display typefaces specially for publications like *Rolling Stone*, *Newsweek*, the *New York Times Magazine*, and the *San Francisco Chronicle*.

Parkinson's initiation into computer design came in 1986 after he began working as a designer for the *San Francisco Chronicle*. When computers were introduced into the art department, he did not initially welcome them. "The computer was actually thrust upon me," Parkinson readily admits. "I was one of those people who said, 'No way are you going to get me to work on one of those things. Those are for kids.'"

California

PARENTING

Regardie's

Newsweek

Esquire

US

Rolling Stone

AMERICAN
PHOTOGRAPHER

Magazine logo design

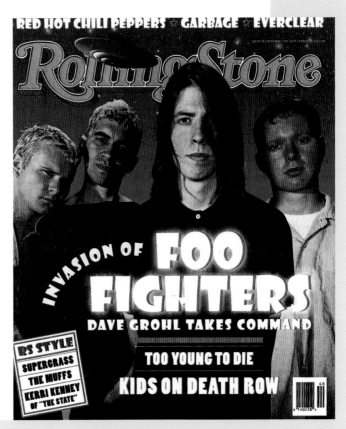

Showcard Gothic used on
Rolling Stone magazine cover

TONIGHT AT 9:30!
SHOUTING IN THE STREETS
INSANE
THEATRICAL CHICANERY & MISCHIEF
PUPPET SHOW
FUNNY SOUND EFFECTS
SPROING
CLANK BOINK CRASH
LOUD CHEERS
STOREFRONT DISPLAY

Showcard Gothic specimen

New Tools of the Trade

Over time, Parkinson's resistance faded and he acquired his first computer, a Macintosh SE, which soon proved too limited for what he wanted to do. He then upgraded to his current system: a Macintosh IIci, a double-page Radius monitor, an Apple OneScanner, and his most recent addition, a 600-DPI Hewlett-Packard LaserJet 5MP. Of the several typeface development applications available, Parkinson's prefers Macromedia Fontographer. Sometimes he will experiment with letters in Adobe Illustrator, and he uses QuarkXPress for graphic design jobs, but when it comes to designing typefaces, Parkinson stays with Fontographer.

Parkinson has come virtually full circle in the use of a computer to create new typeface designs. At first, he used the computer for all phases of a project. Reflecting on his early computer lettering, he states that it was overly determined by the functions peculiar to the computer—functions that were new to him. "Then, the deeper I got into working on the computer," he says, "the more I recognized it as just a tool. I had to learn how to use it to achieve the designs I wanted to do in the first place, rather than let it influence everything."

Showcard Moderne

Laissez les bons temps rouler!

ABCDEFGHIJKLMNOPQR
STUVWXYZ abcdefghijklm
nopqrstuvwxyz1234567890

Designed by Jim Parkinson

Showcard Moderne speciman

The Design Process

Now, Parkinson begins a typeface design by creating rough pencil sketches. He then scans these into the computer and converts the scans into Fontographer files. After continuing to render and fine-tune the individual letters on screen, he prints them out to have closer look at them. Parkinson designs typefaces primarily for print, rather than electronic display, so the way they look on paper is key. Parkinson studies the printout, makes notes, and then produces changes on screen. "I used to print out a letter I was having trouble with, draw changes on the printed character, then re-scan it," he says. "Now everything is drawn on screen—I guess my skill set has changed."

Despite the benefits of using a computer for typeface design, Parkinson also sees limitations. Touching his head with his index finger, he says, "There's not as much distance between here and a piece of paper you draw on, as there is between here and a piece of paper

CONSTRUCTIVE STROKES OF the POPULAR
POSTER LETTERING
ABCDEFGHI
JKLMNOPQ
RSTUVWXYZ

Poster Black sketches

TYPEFACES

1993
ITC Bodoni
(collaborative effort)
EL GRANDE
POSTER BLACK
SHOWCARD
GOTHIC

1994
Parkinson
Parkinson Condensed

1995
Jimbo
Antique Condensed Two
Showcard Moderne

1996
DIABLO
GOLDEN GATE
MATINEE
MOTEL
MOJO
INDUSTRIAL GOTHIC
Generica

that is generated by a computer and comes out of the printer. With the computer, your drawing is not right there at the end of your hand."

With his transition to computer design, Parkinson feels that the nature of his business has changed. He is doing more typeface design and less logo and hand-lettering work. His ongoing work at the *San Francisco Chronicle* also allows him to accept only those commissions that interest him. "Display type is my forte," he says. "That's what I do best. It's type with tons of personality, type that shouldn't be used as text."

Antique Condensed Two
specimen

Matinee specimen

business card

Jim
Parkinson
6170 BROADWAY TERRACE, OAKLAND, CA 94618 USA
Tel. (415) 547-3100

Jimbo

The font Jimbo began in the late 1970s as a hand-lettered logotype for Parkinson's studio. Years later, he presented Jimbo to Adobe Systems, Inc., who immediately gravitated to the font's verve and personality. Adobe wasn't satisfied, however, with just one version of Jimbo; they wanted several—hundreds even. Adobe saw Jimbo as being a natural for their multiple master font technology: a technology that allows many typeface variations to be created from a few design masters.

Perhaps because it was originally based on a somewhat condensed design model, Jimbo's condensed variations are more successful than the extended. The black extended is an exception, but as the design loses weight the extended variants begin to lose a little of the vitality found in the heavier and more condensed versions.

funky funky funky funky funky
funky funky funky funky funky
funky funky funky funky funky
funky funky funky funky funky

Jimbo

Regular
Condensed
Black
Extended

aaaaaaa weight
aaaaaaa width

Jimbo multiple master range

bo

Jimbo speciman

Package 389
$145 $69

NEW! *Jimbo*

A multiple master typeface. 2 axes: weight and width **e**

ABCDEFGHIJKLMNOP
QRSTUVWXYZabcdefgh
ijklmnopqrstuvwxyz
&1234567890

Regular Condensed

ABCDEFGHIJKL
abcdefghijklmn

Regular Normal

ABCDEFG
abcdefghij

Black Extended

ABCDEFGHIJ
abcdefghijklm

Bold Normal

DIABLO

Diablo sketches

In developing Diablo, one of the design problems Parkinson struggled with was whether to make the ends of the individual letter strokes rounded or square. Rounded ends looked more like the work of a Speedball lettering pen, but squared stroke endings made the letters more legible at small sizes. Parkinson's goal wasn't to create a text typeface, but he did want to be sure that his alphabet would be able to be used for a wide variety of jobs.

Although an all-caps design, Parkinson says that he considered creating a lowercase of Diablo, but "a lowercase wouldn't be readable at this weight, and I didn't want to sacrifice the weight of the caps for a lowercase."

Parkinson did, however, draw a series of alternate characters to give the design more versatility. The letters in the lowercase position are pretty straightforward, looking somewhat like a pumped-up sans serif version of ITC Benguiat. These are powerful character shapes, despite the sloping Art Nouveau curves where more standard designs would have a more symmetrical form.

Diablo sketches

Diablo specimen

A B C D E
F G H I J K
L M N O P
Q R S T U
V W X Y Z

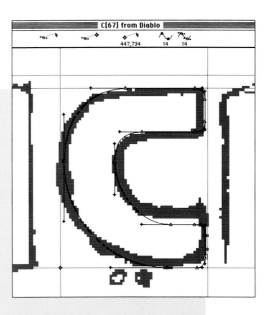

Diablo sketches

Parkinson

TYPEFACES

The typeface Parkinson can trace its lineage back to one of the earliest typeface designs. Its most obvious design influence comes from the Jenson typefaces designed for American Type Founders (ATF) around the turn of the century, but Parkinson's design lineage doesn't stop there. The ATF Jensons were, in turn, heavily influenced by J. W. Phinney's Jenson Oldstyle, released in 1893. Phinney's work was an interpretation of William Morris' Golden Type, and his was a revival of the mid-fifteenth-century fonts of Nicolas Jenson.

Classified as an Oldstyle design, Parkinson has short sturdy serifs, angled stroke weight stress, and, like all good Oldstyles, an angled crossbar on the lowercase "e." Parkinson also incorporates two additional design features not found in most Oldstyle types: narrow lowercase proportions, allowing more of the copywriter's words to be put on a line, and a generous x-height, aiding readability at smaller sizes. Like most of Jim Parkinson's typefaces, this is an industrial-strength design that sure gets the job done.

Parkinson specimen

RECONSTRUCTIO
CONDENSED REGULAR
Ambitious plans for home expansi
MEDIUM
New wing to the southwest will be completed by A
BOLD ITALIC
NEW MARBLE FLOOR
ROMAN
AN AMALGAMATION OF THE FINEST MATERIALS FROM ITALY, COSTA RICA & HOB
LIGHT CONDENSED
Hand-carved
BOLD ITALIC
A level of craftsmanship worthy of the Renaissance Mas
ITALIC
Young student stuns all her teache
CONDENSED LIGHT
BUILDS CIVIC MONUMENT USING ONLY THREE PAPER CL
MEDIUM
Memorial to Famous Dry Cleane
BLACK
WHITE LINEN
ROMAN
Fundraising event left my entire wardrobe caked with m
MEDIUM ITALIC
Loud & Boisterous Shareholde
CONDENSED BOLD
People paid $50 each to arm-wrestle the Board of Direct
ITALIC
CHIEF EXECUTIVE OFFICER STARTED A FOOD FIG
BOLD
Handful of caviar strikes forehea
CONDENSED LIGHT
POLICE ARRIVE TO QUELL HIGH-CLASS DISTURBAN
MEDIUM
TRIAL IN NOVEMBE
BOLD

The Book On CAN ANYONE BEAT DONOVAN BAILEY,
MEN'S SPRINTS

The Book On HERE COMES GWEN TORRENCE, AME
WOMEN'S SPRINTS

Magazine headlines using Parkinson

Magazine spread using Parkinson

an Grumpy wizards make toxic brew for the evil queen and jack. Lazy movers quit hard packing papier-mâché jewelry boxes. Hark! 4,872 toxic jungle water vipers quietly drop on zebras for meals! farm hand (picking just six quinces) proves strong but lazy. Back in my quaint garden: jaunty zinn ie with flaunting phlox. Waltz, nymph, for quick jigs vex Bud. For only $65, jolly housewives made xpensive" meals using quick-frozen vegetables. Sixty zippers were quickly picked from the woven bag. Jaded zombies acted quaintly but kept driving their 31 oxen forward. Six big juicy steaks sizzl

c Grumpy wizards make toxic brew for the evil queen and jack. Lazy movers quit hard packing of pa er-mâché jewelry boxes. Hark! 4,872 toxic jungle water vipers quietly drop on zebras for meals! New hand (picking just six quinces) proves strong but lazy. Back in my quaint garden: jaunty zinnias vie flaunting phlox. Waltz, nymph, for quick jigs vex Bud. For only $65, jolly housewives made "inexpen meals using quick-frozen vegetables. Sixty zippers were quickly picked from the woven jute bag. Jad ombies acted quaintly but kept driving their 31 oxen forward. Six big juicy steaks sizzled in a pan as

ium Grumpy wizards make toxic brew for the evil queen and jack. Lazy movers quit hard pac , of papier-mâché jewelry boxes. Hark! 4,872 toxic jungle water vipers quietly drop on zebras meals! New farm hand (picking just six quinces) proves strong but lazy. Back in my quaint gard aunty zinnias vie with flaunting phlox. Waltz, nymph, for quick jigs vex Bud. For only $65, jolly sewives made "inexpensive" meals using quick-frozen vegetabl ed from the woven jute bag. Jaded zombies acted quaintly but ke

ium Italic Grumpy wizards make toxic brew for the evil queen packing of papier-mâché jewelry boxes. Hark! 4,872 toxic jungle ras for meals! New farm hand (picking just six quinces) proves st arden: jaunty zinnias vie with flaunting phlox. Waltz, nymph, f jolly housewives made "inexpensive" meals using quick-frozen kly picked from the woven jute bag. Jaded zombies acted quaint

d Grumpy wizards make toxic brew for the evil queen and jac of papier-mâché jewelry boxes. Hark! 4,872 toxic jungle wat or meals! New farm hand (picking just six quinces) proves str garden: jaunty zinnias vie with flaunting phlox. Waltz, nymph $65, jolly housewives made "inexpensive" meals using quick s were quickly picked from the woven jute bag. Jaded zombies

d Italic Grumpy wizards make toxic brew for the evil queen d packing of papier-mâché jewelry boxes. Hark! 4,872 toxic k in my quaint garden: jaunty zinnias vie with flaunting phl vex Bud. For only $65, jolly housewives made "inexpensiv etables. Sixty zippers were quickly picked from the woven ju

ck Grumpy wizards make toxic brew for the evil queen an acking of papier-mâché jewelry boxes. Hark! 4,872 toxic j p on zebras for meals! New farm hand (picking just six quin

Magazine spread using Parkinson

The Birth of Little Letters

If you go back far enough, there weren't caps and lowercase letters—there were just letters. The Phoenicians just had one set of letters for their graphic communication. The Greeks made do with the single-size alphabet they inherited from the Phoenicians. The Etruscans only used one style of letters.

Capitals were formal letters, while lowercase letters grew out of handwriting. They started out as caps, but as people began to write them faster, their forms became more relaxed and began to reflect the more fluid movement of the hand.

The first handwritten letters looked much like our present capitals and were called majuscules. Little versions of these letters were called minuscules. Alcuin, an English monk who served as Charlemagne's personal teacher, is generally credited with the creation of these letters. It was Charlemagne, however, that had the power to decree that all official documents and writings were to be written in this style.

Minuscules, or small letters, went by this name until printing with type became popular. Setting type by hand involved working with hundreds of small pieces of metal, so many that shallow trays with boxes for each letter were made to hold and organize them. Big letters were put in one tray (case), while the little letters were put into another. The small letters, being used far more often than the big, were placed for convenience lower and closer to the typesetter; hence upper- and lower-case letters were born.

Jean-François Porchez

Apolline drawings

Normally, it takes several attempts at creating a typeface before a designer is able to capture the public's imagination. Jean-François Porchez is an exception to the rule. Not only did his first typeface design gain recognition, so did his second. His first two creations, FF Angie and Apolline, earned prizes at the International Competition of Typographic Design, sponsored by the Morisawa company.

Porchez studied at École Municipale Supérieure d'Arts et Techniques and received his graduate education at the Atelier National Création Typographique (ANCT), a state-sponsored typography school. After receiving his degree, Porchez worked for three years as type director at Dragon Rouge, a large corporate identity and packaging firm in Paris. Porchez left Dragon Rouge in 1994, choosing to create type and lettering designs on a freelance basis from his apartment studio.

Le Monde drawing

Le Monde newspaper

Apolline romain & alternatives
Il faut conserver à la lettre
Apolline petites capitales & expert
l'aspect d'un dessin
Apolline italique & alternatives
au lieu de lui imposer
Apolline italique expert
une forme géométrique
Apolline demi-gras & alternatives
en un mot la sauver
Apolline demi-gras italique & alternatives
de cette exécutable
Apolline gras & alternatives
perfection :
Apolline gras italique & alternatives
la sécheresse.
Arabesques & ornements 〔✿✵✤❈❋✾✽〕
GEORGE AURIOL

Apolline drawings

Importance of Educators

Porchez says that his interest in lettering and type design began when he was doing graduate work at ANCT. "My intuitive approach was encouraged by my teachers. I was strongly influenced by a very structured form of teaching and my own drawing style." Porchez's first alphabets grew out of his calligraphic lettering and were created as pencil-and-ink drawings on paper. Of his transition from pen and paper to mouse and screen, Porchez says, "What mainly bothered me was the inflexibility of technology and the loss of a degree of sensuality in design."

Although he has created distinctive display designs, Porchez's typefaces tend to be conservative exercises intended primarily for text reading. He says the main goal of his work is to "serve the author and the reader. Unlike some of my type designer friends who draw alternative and experimental display designs, I do not want to add more concepts to my work; I practice 'invisible typography.'"

Logotypes

Truffon	Spanghero	Minitroulet	Royal cône
TECNIFIBRE	LES PÊCHERIES DE·NOSSI·BE	LA POSTE	PEAUDOUCE
GL Guy Laroche	Le Monde	VALVERT	La Villageoise
MONT ST·MICHEL	Duetto	Tonigencyl	Plancoët
MAROUSSIA	Papeterie	TOURTEL	CHRONOPOST
Double douceur	BRUMMELL CLUB	Banania	Info Matin

Apolline drawings

1994
FF Angie

1995
Apolline
Le Monde
ANISETTE

1996
Parisine

Porchez Typofonderie brochure

ACHETEZ DES CARACTÈRES
TYPOGRAPHIQUES DIRECTEMENT CHEZ LE CRÉATEUR

Specimens *de*
CARACTÈRES
& ORNEMENTS
typographiques
Créés par Jean-François Porchez

☞ PORCHEZ *Typofonderie* distribue des
caractères de haute qualité pour typographes avertis
(demandez la liste des prix). Elle conçoit & produit
également des caractères d'entreprise
répondant à des besoins
spécifiques.

PORCHEZ *Typofonderie*

www.porcheztypo.com *(web)*
38 bis avenue Augustin-Dumont
92240 Malakoff, France
33 (0)146 542 692 *(téléphone & fax)*
jfporchez@hol.fr *(E-mail)*

1998

Le Monde drawing on screen

Apolline specimen

Jean-François Porchez

Le Monde

Le Monde drawing

TYPEFACES

The summer after he left Dragon Rouge, Porchez learned that the French newspaper *Le Monde* had plans to graphically reinvent itself for its fiftieth anniversary. Porchez was able to sell the publication's editors on the idea of a new typeface to coincide with the other redesigned aspects of the newspaper. Not only would the paper have a new look, but Porchez was able to demonstrate how his proposed typeface would also increase the paper's readability.

His initial design model was a Macintosh version of Times New Roman, but tailored to meet the needs of the French daily. Porchez sees social implications in the work of designing a newspaper typeface. "It's not like *Ray Gun* or *Emigre*, that attract readers who come to those publications for the look and for specific content and will read them in any case," he says. "A daily newspaper has to appeal to the widest range of readers possible and make reading easy for them. If a typeface can make information more accessible, it performs a service to the public."

Le Monde Newspaper

Le Monde Journa

Le Mon

Le Monde specimen

La vie de Verdi n'est pas un opéra

r la première fois, on peut lire en français une biographie du compositeur italien :
où l'on découvre un homme réservé, resté en retrait du monde du théâtre

OI
illips-Matz.
ais (Etats-Unis)
n,
hèque des grands
6 p., 250 F.

ans, les éditions
aient publié un
opéras de Verdi,
s la direction de
t où l'on trouvait
chaque ouvrage,
ue ou son résumé
mmentaire musi-
t. Pour étudier les
e la dramaturgie
eut lire le remar-
Gilles de Van, *Ver-
musique* (Fayard,
compositeur lui-
ence d'une véri-

connaissait seulement le droit d'applaudir ou de se taire. A l'évidence, pourtant, il aimait composer pour le théâtre mais, quand la partition devait affronter les aléas de la création, il ne mesurait que trop le fossé entre l'idéal entrevu et la réalité.

Restant à distance des chanteurs et des chanteuses, il fit exception pour deux cantatrices, Giuseppina Strepponi, qu'il épousa secrètement après une liaison de quinze ans, et Teresa Stolz, qui prit un moment la relève dans son cœur. Si ce n'est pas absolument tout, il semble que la vie sentimentale de Verdi ait été rien moins que débridée. Son patriotisme ne fait aucun doute, mais s'il paya des fusils pour aider à l'unité italienne qu'il appelait de ses vœux, s'il ren-

Le Monde
Le Monde
Le Monde
Le Monde

Le Monde	Le Monde	Le Monde	Le Monde
Le Monde	*Le Monde*	*Le Monde*	*Le Monde*
Le Monde	Le Monde	Le Monde	Le Monde
Le Monde	*Le Monde*	*Le Monde*	*Le Monde*
Le Monde	**Le Monde**	**Le Monde**	**Le Monde**
Le Monde	***Le Monde***	***Le Monde***	***Le Monde***

Le Monde
Le Monde
Le Monde
Le Monde

Le Monde drawing

Le Monde Livre

Monde

Le Monde Courrier

ans

Le Monde/Superposition

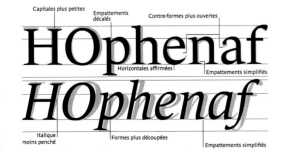

Capitales plus petites
Empattements décalés
Contre-formes plus ouvertes

HOphenaf

Horizontales affirmées
Empattements simplifiés

HOphenaf

Italique moins penché
Formes plus découpées
Empattements simplifiés

File Edit View Element Points Metrics Windows Hints Jeu 16•59

LeMondeJournal-Normal0sF LeMondeJournal-Normal0sF : i [105]

View by: Width Name: i Uni code: 0069
 Key: i Dec: 105 Hex: 69

Le Monde drawing on screen

Jean-François Porchez

Parisine

The Parisine typeface was first created as a type for the signage and print materials of the Paris Metro subway system. The RATP wanted to change the signage system to a typeface that had both capitals and lowercase letters to improve the legibility of the signs at over three hundred Metro stations in and around Paris.

At first glance, Parisine may appear to be very similar in design to Helvetica, but a closer look reveals many subtle and important differences. First, the capitals are generally narrower in proportion in Parisine than in Helvetica. This enables them to blend better with the lowercase letters and helps address the space-efficiency requirements. Porchez incorporated other design traits to make Parisine space-efficient and improve legibility.

Although not as important to the design as in Le Monde, Parisine is also a design with horizontal overtones.

Aa Bb Cc Dd Ee
Ff Gg Hh Ii Jj Kk
Ll Mm Nn Oo Pp
Qq Rr Ss Tt Uu
Vv Ww Xx Yy Zz

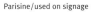

Parisine/used on signage

Parisine/Helvetica comparison

Classifying Type

Most typefaces can be divided into two categories: those with serifs and those without. Over the years, to further classify typeface design traits, several more definitive classification groups have been developed— some with over a hundred different categories. While two categories of type are inadequate for any meaningful work, hundreds also become self-defeating. The following system uses sixteen basic groups that provide a good start for classifying typeface designs by style.

Futura

News Gothic

City

Gill Sans

TRAJAN

Memphis

Clarendon

Baskerville

Bodoni

Berkeley

Brush Script

Zapf Chancery

Blackletter

Kunstler Script

Antiques

GESTALT

Geometric Sans Serif

Typefaces using simple geometric shapes. Character strokes have the appearance of being strict monolines, and character shapes are made up of seemingly perfect geometric forms.

Sans Serif Grotesque

These typefaces have a slight squared quality to many of the curves, and several designs have a roman-style bowl-and-loop lowercase "g."

Square Sans

These designs are generally based on grotesque character traits and proportions, but they have a definite squaring of normally curved strokes.

Humanistic Sans Serif

Based on the proportions of Roman inscriptional capitals and lowercase letters. A contrast in stroke weight is readily apparent and some designs have a strong calligraphic influence.

Glyphic Serif

This category tends to reflect lapidary inscriptions rather than hand-drawn text. A distinguishing feature of many such typefaces is a triangular serif design, or a flaring of the character strokes where they terminate.

Slab Serif

These typefaces have very heavy serifs with little or no bracketing. Slab serif type styles appear to be sans serif designs with the simple addition of heavy serifs.

Clarendon

Clarendons have a strong vertical weight stress. Contrast in stroke thickness is not nearly as dramatic as in the Didones. Serifs are normally heavy, bracketed, and usually square-cut.

Transitional

Character strokes generally have a vertical stress to them. The weight contrast is more pronounced than in Oldstyle designs. Serifs are bracketed and head serifs are oblique.

Neo-Classical and Didone

Contrast between thick and thin strokes is abrupt and dramatic. The axis of curved strokes is vertical, with little or no serif bracketing. Often, stroke terminals are ball shaped.

Oldstyle

The axis of curved strokes is normally inclined to the left with weight stress at the eight- and two-o'clock positions. Serifs are almost always bracketed and head serifs are often angled. Some versions are distinguished by the diagonal cross stroke of the lowercase "e."

Casual Script

Designed to look informal or quickly drawn with a brush or pen. The individual letters do not generally connect with each other.

Calligraphic Script

These are script faces that mimic calligraphic writing. They can be connecting or non-connecting in design and they almost always appear to have been written with a flat-tipped writing instrument.

Blackletter and Lombardic Script

These are typefaces patterned to look like manuscript lettering prior to the invention of movable type.

Formal Script

These generally imitate eighteenth-century formal writing styles copied from the writing masters of a century earlier. Normally character strokes connect one letter to the next.

Antiques, Art Nouveau, and Art Deco

These are typefaces designed to look like those used for display work between the mid-1800s and the early 1900s. Many of today's designs are, in fact, revivals of fonts used during this time period.

Decorative

Can look like stencil-cut letters, seem decorated with flowers, or appear to be three-dimensional. Some use unorthodox letter shapes and proportions to achieve distinctive and dramatic results.

QUAY & SACK

David Quay has strong opinions about virtually everything typographic. He contends that typefaces drawn on screen are almost always flawed. "They lack the human vitality induced by the fulcrum of the wrist and the elbow." Quay also claims that he can always spot a typeface designed with a computer. Although Quay's ability to identify typefaces designed through the aid of computer technology has never been formally tested, it is true that even though his hundreds of typeface designs almost always end up as digital fonts, he is one of the few type designers who does not include computers and software as part of his design tool kit.

Quay's outspoken typographic opinions demonstrate his deep commitment to the art, history, and business of type. As well as running David Quay Design, he has lectured extensively on type and typography at the Designskole in Copenhagen and the London School of Printing in England. He has been the British representative for the Type Directors Club of New York and is joint chair, with Freda Sack, of the London-based International Society of Typographic Designers.

The Other Half of the Design Team
Freda Sack, Quay's design partner, has always shared his enthusiasm for type. Sack also takes no back seat to Quay in her typographic convictions—but she is less extroverted in expressing them.

While Quay was trained as a graphic designer and slowly gravitated to the typographic arts after graduating from Ravensbourne College of Design and Communication in England, Sack always drew letters. She began her career at Letraset as an apprentice letter cutter in the early 1970s and never left letterform design. After Letraset, Sack worked for Fonts in London as a senior type designer, and in 1980 she was recruited back to Letraset as part of the company's plan to develop new typeface designs for license to font foundries. Like Quay, Sack devotes much of her

time to the typographic community. She teaches and she is a member of Letter Exchange and the Typographic Circle in London.

With a studio based in the Soho section of London, the duo normally works independently but comes together for most type-related projects. Theirs is the give-and-take relationship of two fiercely independent people who have worked closely for many years. "It has been known for David to screw up something he's been drawing on and throw it on the floor, and for me to pick it up, flatten it out, and hand it back to him to fix," says Sack. "But we almost always have a very clear idea of what we want from our designs and tend to share the same feeling when it comes to type design projects."

The Foundry

In 1990, Quay and Sack launched The Foundry as an independent type design office dedicated to creating, marketing, and distributing fonts to the graphic design community. An important goal of The Foundry is to give the duo control over the typefaces they create. While the work they do for corporate clients is rewarding, they say, "It is often full of the compromises necessary to satisfy a client's needs, wishes, and whimsies." The Foundry was formed as a vehicle to allow Quay and Sack to work on "typefaces that we want to do, the way we want to do them."

No Computers Here

Something that separates The Foundry from virtually every other modern type supplier is that it has no internal capacity for digitizing artwork. "You don't have to go near a computer to start your own foundry if you know the right people," claims Quay. "All The Foundry faces are drawn by hand, with a 9H pencil on tracing vellum." The finished drawings are then sent to a company called Applied Image Technology, which uses the very high-end, sophisticated, and numbingly complicated Ikarus software running on a mainframe computer to convert these analog renderings into digital art. Quay and Sack do, however, use computers for their other design projects but swear that their typefaces are untouched by computer technology until all the creative work is done.

Typeface drawings can take from six weeks to two years to complete. Individual letters are sketched, edited, and modified several times as renderings on tracing vellum before the duo is satisfied with the results. "After twenty years we're getting pretty good at it," says Quay with a smile. "The designs are about ninety-nine percent there by the time we send them to John Clements at Applied Image Technology."

Trial fonts are made, a printout is generated, and another series of edits and design modifications takes place before new typefaces are released to clients or the type-buying public.

original new wave fonts

Recently Quay and Sack have revived a number faces collectively called the Architype series that are based on the work of artists whose work helped to shape the design philosophies of the Modernist movement in Europe. The series comprises twelve typefaces broken into two groups.

The quest for inspiration for these faces led Quay and Sack to the Bauhaus Archive in Berlin and the Rijksmuseum Kröller-Müller in Otterlo. In some cases the two had to complete the fonts' character sets working only from sketches or a few letters drawn for a poster. The finished designs, however, are always true to the spirit of the originals.

Architype

ARCHITYPE AUBETTE

architype

architype bayer-type

Quay and Sack's Architype Bayer-type captures all the idiosyncrasies and verve of Bayer's sketches prior to the manufacture of Berthold's font. Bayer-type is based heavily on Bayer's earlier sans serif Universal typeface but is a Modern, or Didone, design. Proportions are the same as the earlier design, as are the basic character shapes. Letters are created out of simple shapes and are optically the same width. Descenders and ascenders are diminutive, and the contrast between thick and thin character strokes is abrupt and dramatic. The result of these design traits is a design that is dramatic but, unfortunately, not very reader-friendly.

ARCHITYPE SChWITTERS

Alternate letters and distinctive character designs make Quay and Sack's revival of Kurt Schwitters lettering a great display face. It is a monocase design, using both capital and lowercase letterforms. Included in the font is an alternative set of characters that are virtual opposites in design to the standard set. Mixing the standard and alternate characters in the same word produces discordant, vibrant, yet surprisingly readable typography. This is a design that breaks all the rules and still manages to work as an admirable display typeface.

nner Bold

Architype Albers

architype ballmer

bayer-type

ARCHITYPE SChWITTERS

TYPEFACES

ARCHITYPE AUBETTE

Architype Aubette is based on van Doesburg's letter-
ing for the Café L'Aubette and could be a not-so-dis-
tant relative to ITC Machine: all characters are based
on a square design motif and are optically the same
width. Stroke weights are heavy, and only capital
letters are available in the design. While this is essen-
tially a sans serif design, several characters, such as
the "D," "K," "M," "N," and "Y," have vestigial serifs that
give the typeface an almost Cyrillic flavor. Architype
Aubette also comes with a set of special numbers con-
tained in boxes, diamonds, and circles.

Architype Renr

ARCHIT

AA

architype tschichold

Named for Jan Tschichold, who designed a monocase sans serif typeface and published fervent arguments in favor of the use of sans serif type, Architype Tschichold is an exact rendering of his original 1929 monocase design. It is the lightest typeface in the Architype series, and perhaps the most pleasing to the eye. Numbers and punctuation have been added, but the phonetic symbols in the Architype font are based on Tschichold's original alphabet, which included a large array of phonetic characters. The result is a type that has the variety necessary for easy reading.

architype bayer

r

PE VAN DER LECK

HITYPE VAN DOESBURG

architype tschichold

architype bill

Single Alphabets

As early as 1617 Robert Robinson experimented with the design of a single-alphabet typeface. Over two hundred years later, Isaac Pitman also produced a prototype single-alphabet typeface. Both of these typographic experiments eliminated capital-letter designs as being superfluous.

Many of the Architype designers' experimental works were also directed toward creating a single-alphabet design, the idea being that caps and lowercase were unnecessary and that pure letter shapes were all that was needed for clear, efficient typography.

Whether you subscribe to this theory or not, it is interesting to note that each of the Architype designers attacked the problem in a slightly different way. Schwitters used a combination of capital and lowercase letters in his design. Tschichold followed Schwitters' example but added calligraphic script letterforms to his Universal alphabet. Van Doesburg used all capitals for Aubette, while Bayer used only lowercase letterforms.

Over the years many typographic pioneers have experimented with a common, or single-alphabet, typeface. None of these designs, however, have stood the test of time.

Schwitters
van
Doesburg
bayer

DESIGNER

Robert Slimbach

G G G G G G
G G G G G
G G G G G G
G G G G G
G G G G G
G G G G G
G G G G G G
G G G G G G
G G G G G G
G G G G G G

Minion multiple master from 6 to 72 point size

hand drawn lettering

Robert Slimbach never boasts about his work and rarely talks about his typeface designs. His modesty, however, does an injustice to the broad body of type-face families he has created, among them Adobe Utopia, ITC Slimbach, ITC Giovanni, Adobe Garamond, Poetica, Minion, and Adobe Jenson. So much of his work has been done on commission or as an employee that it is easy to overlook the scope of his achievements.

Slimbach's interest in lettering began in the early 1980s when he was producing serigraph prints, some of which incorporated lettering. "I had no formal training in lettering and typically would refer to old Letraset type catalogs as a reference for the hand-drawn titles in my prints." In 1983 Slimbach began working in the type drawing department at Autologic, the California-based manufacturer of typesetting equipment. "I took the position with the intention of making some extra money to finance my pursuits of printmaking and painting," he recalls. "But it didn't take long before I began designing typefaces." Slimbach's first job at Autologic was recreating metal and phototype faces for digital technology. At that time, however, he also began to develop his own orig-inal typefaces in the evenings after work, encouraged by Autologic design director Sumner Stone.

, proud sphere of earth, speed on

Вращайся, гордый шар земной,

d never cease to whirl!

и никогда не прекращайся!

t for one favor I'm still pleading-

Прошу о милости одной-

n't for long yet bid me farewell.

со мной подольше не прощайся.

Minion Italic sketch

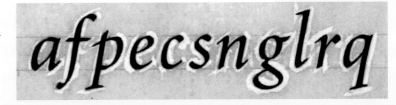

First of Many

Slimbach's first typeface, ITC Slimbach, was drawn for International Typeface Corp. and came about as the result of a worldwide talent search ITC undertook in the mid-1980s. During the search, ITC saw literally hundreds of typeface designs from designers throughout Europe and the United States, but Slimbach's was the only one they chose to release. Shortly after ITC released his first typeface, Slimbach left Autologic to work full time on his own designs.

While working on his second ITC typeface, Slimbach learned that Sumner Stone had relocated to northern California and was working for a small start-up company called Adobe Systems, Inc. He called Stone to seek some advice on the design of the ITC typeface, but before he hung up the phone, Stone had invited Slimbach to Adobe for a tour of the design department. Less than a month later he was hired as a type designer for Adobe. Since then, all of Robert Slimbach's typefaces have been designed for the software giant.

Although he works for a cutting-edge software developer, Slimbach still believes that the process of drawing letters by hand is the best way to flesh out a new design. "These are spontaneous activities in which mood and inspiration translate directly and quickly to the work at hand," he says. He also finds that "new ideas flow easily, and there are many opportunities for happy accidents to appear."

"Designing type is a long process in which one usually begins with a rough idea that is refined over time to an ever-increasing level," says Slimbach. "I think a good analogy might be a sculptor, working with a huge piece of marble. The sculptor has a idea to make something, and when he's chiseled the basic image, then the very last part—getting every fingernail and detail perfect—probably takes a long, long time."

Minion specimen

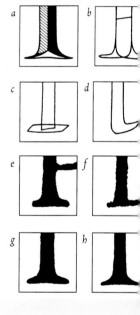

Minion specimen

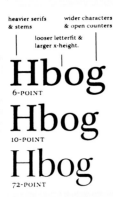

heavier serifs & stems

wider characters & open counters

looser letterfit & larger x-height.

Hbog
6-POINT

Hbog
10-POINT

Hbog
72-POINT

Kepler comparison

Minion multiple master primary fonts

Each multiple master typeface is supplied with a set of primary fonts that comprise a complete, ready-to-use typeface family. In addition to the custom fonts that can be generated along the optical size, weight, and width axes, Minion multiple master and Minion Italic multiple master each include the eight pre-built primary fonts listed on this page. Each primary font contains the standard set of characters, Expert Sets, and alternate sets of Italic Swash Capitals and Ornaments. (Note that ornaments can be adjusted only along the optical size axis.) See the *Adobe Multiple Master User Guide* for detailed information on Multiple Master font names.

light	light	light	light	light	light	light
light	ᵃ light	light	light	light	ᵈ light	light
light	light	light	light	light	light	light
light	light	light	light	light	light	light
light	ᵇ light	light	light	light	ᵉ light	light
light	light	light	light	light	light	light
light	ᶜ light	light	light	light	ᶠ light	light
light	**light**	**light**	**light**	**light**	**light**	**light**

The Minion & Minion Italic primary font names as they appear in the font menu

ᵃ 367 RG 465 CN 11 OP	regular condensed	ᵈ 367 RG 585 NO 11 OP	regular normal
ᵇ 485 SB 465 CN 11 OP	semibold condensed	ᵉ 485 SB 585 NO 11 OP	semibold normal
ᶜ 578 BD 465 CN 11 OP	bold condensed	ᶠ 578 BD 585 NO 11 OP	bold normal
		ᵍ 367 RG 585 NO 72 OP	display normal

Axis abbreviations

weight	width	size
RG regular	NO normal	OP optical size
SB semibold	CN condensed	
BD bold		

Minion multiple master
primary fonts

light — 6-point

light — 12-point

light — 18-point

light — 24-point

light — 30-point

light — 42-point

light — 48-point

light — 54-point

light — 60-point

light — 66-point

light — 72-point

Typography

Kepler comparison

Adobe Jenson

Adobe Jenson sketches

Adobe Jenson, the company's first multiple master historical revival, is a recent Slimbach release. Slimbach used Adobe's interpolation technology to replicate the changes in style and proportion necessary when creating various sizes from a single size of a metal typeface.

Adobe Jenson is a two-axis multiple master typeface, and it is the first Jenson revival that allows font variations to be made in weight and optical size. Slimbach's renditions of Jenson's roman, and italics based on Ludovico degli Arrighi's, retain the feel of the original hand-cut types while adhering to contemporary typographic convention.

Interpreting Jenson's letterforms in the digital medium required special care. The subtleties of Jenson's original type do not always align on a grid. Although a certain amount of consistency is desirable in a digital typeface, Slimbach made a special effort to retain many of the irregularities and idiosyncrasies of Nicolas Jenson's original font.

Original Jenson

Nicolas Jenson was influenced by Classic Roman inscriptions on buildings and monuments. In formulating the typeface Jenson, he melded the elements of inscriptional lettering and calligraphy. Prior to Jenson, typefaces were patterned almost solely on the quill pen and brush work of the manuscript writer. Printing was still in its infancy and, as with most technologies, the first examples of its use mimicked the previous work.

Much of the appeal and warmth of Jenson's type comes from its rugged appearance. As a designer of metal typefaces, Nicolas Jenson engraved each letter, in reverse, on the end of a steel rod, or punch. Each letter was a unique, hand-crafted element, and slight variations in stem width, alignment, and shape were unavoidable. The resulting idiosyncrasies and sculptural letter shapes provide Jenson with its unique appearance.

Adobe Jenson sketches

aaabb
dddeeefffgggg

heavier serifs | looser lette
& stems | & larger x-
wider characters
& open counters

Hmfg
6-POINT

Hmfg
12-POINT

Hmfg
72-POINT

Adobe Jenson comparison

Adobe Jenson specimen

Adobe Jenson Multiple Master Primary Fonts

Each multiple master typeface includes a set of primary fonts that make-up a complete, ready-to-use typeface family. In addition, to the custom fonts that can be generated along the optical size and weight axes, Adobe Jenson multiple master and Adobe Jenson italic multiple master each include the nine pre-built primary fonts shown below. Primary fonts are available for the standard and expert set of characters, as well as swash italic and alternate roman and italic sets.

ABCDEFG
HIJKLMN
OPQRST
UVWXYZ
abcdefghij
klmnopqrs
tuvwxyz
1234567890

6 8 10 12 14 16 24 36 54 72

The Adobe Jenson primary font names as they appear in the font menu.

a	371 rg	8 op	Reg 8 OpSize
b	506 sb	8 op	SemBld 8 OpSize
c	590 bd	8 op	Bold 8 OpSize
d	371 rg	12 op	Reg 12 OpSize
e	506 sb	12 op	SemBld 12 OpSize
f	590 bd	12 op	Bold 12 OpSize
g	371 rg	36 op	Reg 36 OpSize
h	506 sb	36 op	SemBld 36 OpSize
i	590 bd	36 op	Bold 36 OpSize

Key to abbreviations.

weight **size**

RG regular OP optical size
SB semibold
BD bold

Adobe Jenson multiple master primary fonts

Robert Slimbach

1234567890

TYPEFACES

In addition to Oldstyle and calligraphic types, Slimbach is also fond of modern, or Didone, typefaces. While Utopia has a modern flavor to it, Slimbach takes a bigger step toward creating a true modern typeface with Kepler.

In Kepler, Slimbach sought a modern typeface that was more friendly and inviting than traditional examples of the style, which tend to be highly mannered designs that are obviously constructed, rather than drawn. Slimbach tried to make a design that reads well at all sizes. Taking advantage of the multiple master capability, he modified character shapes and weights and created a design in which the character stroke contrast is stronger and more dramatic when large-size designs are chosen.

As designs for smaller sizes are chosen, the stroke weight changes to a more modulated contrast of thick and thin. When seen side-by-side and scaled to the same size, the five-point and seventy-two-point masters appear notably different. The result is a modern-style typeface that works well at both very large and very small sizes.

Kepler

the quick brown fox
jumps over lazy dog
abcdefghijklmnop
qrstuvwxyz12345
67890 abcdefghij

Kepler sketches

Kepler ornament sketches

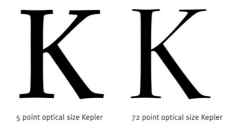

5 point optical size Kepler 72 point optical size Kepler

Kepler comparison

ABCDEFGHIJKLM
abcdefghijklmnop
1234567890123456

ABCDEFGHIJKLMNO

ABCDEFGHIJKLM
abcdefghijklmnopq
1234567890123456

ABCDEFGHIJKLMNOP

ABCDEFGHIJK
abcdefghijklmnopq

Sturdy

Delicate

Progressive

Classical

Expressive

Utilitarian

Practical

Skinny

Stately

BRASH

Decorative

BOLD

Kepler specimen

What's a Multiple Master?

Multiple master is a technology that provides a graphic designer with unheard of control over font parameters in creating customized fonts that maintain the integrity of a typeface design. In making a multiple master typeface, a type designer creates master designs at each end of a design axis (parameter) within a single electronic font. These axes can include such aspects as weight, width, style, and optical size.

Each multiple master typeface contains two or more sets of master designs that determine the dynamic range of each design axis in the typeface. For example, when light and black master designs represent the extremes of the font's weight axis, any variation that falls within this dynamic range can be generated. The advantage to this technology lies in the ability to customize all aspects of a font to fit virtually any measure, as well as compensating for the inherent differences in a font's appearance with various printing technologies or papers.

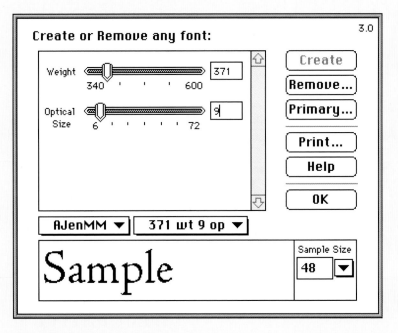

screen shot of multiple
master controls

Is There Any Bad News?

Multiple master typefaces take up considerably more memory than single-face fonts. Although change is always in the air, Macs take a larger memory hit than PCs for each new variation, or *instance*, created. Multiple master instances appear in the font menu just like other fonts, so if many are created, the font menu can get long. With numerous variations, multiple master types can't go by descriptors such as condensed or bold. Instead, instances are designated by alphanumeric identifiers. Also, page-layout applications do not support the optical sizing aspect of multiple master typefaces in an automatic manner. This means that each time a point size change is made in a document, a new instance of the correct design for the size being used must also be created, or chosen from the font menu if it has already been made. Successful use of multiple master fonts also requires considerable design experience.

Who's Making Multiple Master Fonts?

Right now Adobe Systems Inc. is the predominant supplier of multiple master fonts. Multiple master fonts are difficult to make and take a tremendous commitment of time and expertise on the part of a font vendor to bring to market. However, other vendors such as Alphabets, Inc., the Hoefler Type Foundry, and Monotype have gotten their feet wet developing multiple master typefaces.

Some of the possible multiple master design axes

DYNAMIC RANGE	DESIGN AXES

multiple master comparison

weight — light to bold

width — condensed to extra-extended

style — sans serif to serif

optical size — 6-point to 72-point (scaled to same size)

Erik
Spiekermann

DESIGNER

Born in Berlin in 1947, Erik Spiekermann financed his studies in art history at Berlin's Free University by running a printing press and setting metal type in the basement of his house. After having spent seven years as a freelance graphic designer in London, he returned to Berlin in 1979, where, together with two partners, he founded MetaDesign. MetaDesign currently employs more than 150 people, making it the largest design studio in Germany. MetaDesign San Francisco and MetaDesign London now add to the blend of "teutonic efficiency with an Anglo-Saxon sense of humor," as one journalist described MetaDesign's work. Worldwide clients include Adobe, Apple, Audi, Hewlett-Packard, IBM, Texas Instruments, and Volkswagen.

An accomplished type designer, graphic designer, and typographic consultant, Spiekermann is also a principal of The FontShop, a company dedicated to supplying graphic communicators with traditional fonts and new designs from young designers.

When asked what kind of system he uses for typeface design, Spiekermann quips, "Two hands, two eyes, and one brain." If pushed, he will admit that he is quite capable of using a Mac and he claims to be the first German designer to own a Macintosh computer, but he says he relies on his mind to solve design problems. "Computers are for production," according to Spiekermann. "The mind is for designing. Designing is different from production. Designing for me is sketching, working towards the mental image I have of a letter. Production is digital, using Macromedia Fontographer to sketch faces or Ikarus M to digitize outlines."

Spiekermann sees himself as a problem-solver, not an artist, when it comes to typeface design. The process of beginning a new typeface is simple and straightforward. "Identify a problem, like space-saving, bad paper, low-resolution, on-screen use, then find typefaces that almost work but could be improved. Study them. Note the approaches and failings. Sleep on it, then start sketching without looking at anything else."

Hamburg
Hamburg
Hamburg
Hamburg
Hamburg

bdfgijln million million
bdfgijln million million
bdfgijln million million
bdfgijln million million
bdfgijln million million

Erik Spiekermann

ITC Officina

TYPEFACES

The design challenge in creating ITC Officina was to bridge the gap between old-fashioned typewriter type and a traditional typographic design. The goal was to create a small family of type suited to the tasks of office correspondence and business documentation. Spiekermann presented the concept at one of ITC's review board meetings in the late 1980s. At the time, desktop publishing was only a couple of years old, and the review board thought that office users might need a little help in weaning themselves from the typewriter.

Production tests showed that ITC Officina could stand on its own as a highly legible and remarkably functional type style. Proportionally, the design was kept somewhat condensed to make it spatially economical. Spiekermann also took care to insure that counters were full and serifs (in the serif version) sufficiently strong to withstand the rigors of small sizes, low-resolution output devices, and less-than-ideal paper stock.

ITC Officina

ITC Officina was originally conceived as a typeface to bridge the gap between old fashioned typewriter type and a traditional typographic design. The design goal was to create a small family of type ideally suited to the tasks of office correspondence and business documentation.

What developed is a different sort of type family. It has a distilled range of two weights: Book and Bold (medium weight being unnecessary in office correspondence) with complementary Italics. In addition, ITC Officina available in two styles: Serif and Sans. The end is an exceptionally versatile communication to packaged in a relatively small type family.

Midway through the design, however, it became obvious that this face had capabilities far beyond its original intention. Production tests showed that ITC Officina could stand on its own as a highly legible and remarkably functional type style.

The European design team, under the close guidance of the Berlin designer, Erik Spiekermann, was given the directive to continue the work on ITC Officina, but now with two goals. The first was to maintain the original objective of the design: to create a practical and utilitarian tool for the office environment. And the second was to develop a family of type suitable to a wide range of typographic applications.

Proportionally, the design has been kept somewhat condensed to make the family space economical. Special care was also taken to insure that counters were full and serifs sufficiently strong to withstand the rigors of small sizes, modest resolution output devices, telefaxing, and less than ideal paper stock.

ITC Officina specimens

ITC Officina Serif

Officina	**OFFICINA**
Officina	*OFFICINA*
OFFICINA	**Officina**
OFFICINA	*Officina*
Officina	**OFFICINA**
Officina	*OFFICINA*
OFFICINA	**Officina**
OFFICINA	*Officina*
Officina	**OFFICINA**
Officina	*OFFICINA*

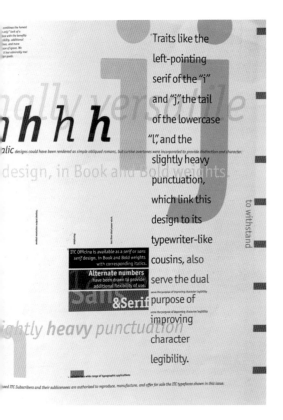

Traits like the left-pointing serif of the "i" and "j", the tail of the lowercase "l", and the slightly heavy punctuation, which link this design to its typewriter-like cousins, also serve the dual purpose of improving character legibility.

123456789
123456789

Specimen book for ITC Officina

HAMBURGERFONTSI
Hamburgerfontsi
Hamburgerfontsi
Hamburgerfontsi
Hamburgerfontsi
HAMBURGERFONTSI
Hamburgerfontsi
Hamburgerfontsi
Hamburgerfontsi
Hamburgerfontsi

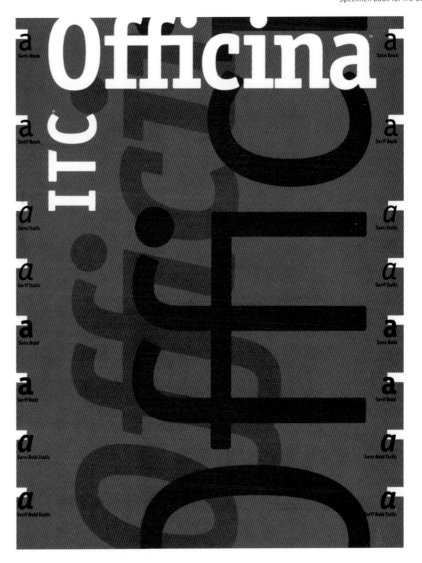

FF Meta

In 1984, Spiekermann persuaded the German post office to commission an exclusive typeface to be used for all its printed material. Spiekermann had already started developing a corporate design program for this state-owned agency, which was using a large and diverse mix of typefaces from a variety of sources. He suggested that an exclusive typeface would give a coherent look to the thousands of forms, brochures, advertisements, and telephone books produced by the post office.

By late summer two fonts were available for testing. These were printed and approved, but before the new designs were officially accepted, the whole project was canceled. The client decided to use Helvetica instead.

Four years later, when software became available to digitize characters, Spiekermann took the original drawings and brought out Meta.

Hamburg
Helvetica
Hamburg
Frutiger
Hamburg
Gill
Hamburg
News Gothic
Hamburg
Syntax
Hamburg
Meta

MetaNormal
MetaCondNormal
MetaNormal
MetaNormal
MetaNormal
MetaBook
MetaCondBook
MetaBook
MetaBook
MetaBook
MetaMedium
MetaCondMedium
MetaMedium
MetaMedium
MetaMedium
MetaBold
MetaCondBold
MetaBold
MetaBold
MetaBold
MetaBlack
MetaCondBlack
MetaBlack

BDH
abcdeghi
mnoprst
145

Deutsche Bundesp

Dorothea geht mit Dorothea geht mit Dorothea ge
Hammer und Degen Hammer und Degen Hammer und
Dorothea geht mit Dorothea geht mit Dorothea ge
Hammer und Degen Hammer und Degen Hammer und

Hamburg
Hamburg
Hamburg
Hamburg

burg
burg

22

1 (415) 627 0790

49 30 695 79 200

abcdefghijklmnopqrst
uvwxyzßABCDEFGHIJKL
MNQPRSTUVWXYZ(/.:;‐
12345677890&
abcdefghijklmnopqrst
uvwxyzßABCDEFGHIJKL
MNQPRSTUVWXYZ(/.:;‐
12345677890&
**abcdefghijklmnopqrst
uvwxyzßABCDEFGHIJKL
MNQPRSTUVWXYZ(/.:;‐
1234567890&**

FF Meta plus Normal (with CAPS, *Italic* & *CAPS ITALIC*)

Handgloves 123 HANDGLOVES 456
Handgloves 78 HANDGLOVES 90
ABCDEFGHIJKLMNOPQRSTUVWXYZ
····⟩ abcdefghijklmnopqrstuvwxyzß
⟨···· fi,ffi.1234567890 & 1234567890

FF Meta plus Book (with CAPS, *Italic* & *CAPS ITALIC*)

Handgloves 123 HANDGLOVES 456
Handgloves 78 HANDGLOVES 90
ABCDEFGHIJKLMNOPQRSTUVWXYZ
····⟩ abcdefghijklmnopqrstuvwxyzß
⟨···· fi,ffi.1234567890 & 1234567890

FF Meta plus Medium (with CAPS, *Italic* & *CAPS ITALIC*)

Handgloves 123 HANDGLOVES 456
Handgloves 78 HANDGLOVES 90
ABCDEFGHIJKLMNOPQRSTUVWXYZ
····⟩ abcdefghijklmnopqrstuvwxyzß
⟨···· fi,ffi.1234567890 & 1234567890

FF Meta plus Bold (with CAPS, *Italic* & *CAPS ITALIC*)

Handgloves 123 HANDGLOVES 456
Handgloves 78 HANDGLOVES 90
ABCDEFGHIJKLMNOPQRSTUVWXYZ
····⟩ **abcdefghijklmnopqrstuvwxyzß**
⟨···· **fi,ffi.1234567890 & 1234567890**

FF Meta plus Black (with *Italic*)

Handgloves 123 *Handgloves 456*
ABCDEFGHIJKLMNOPQRSTUVWXYZ
····⟩ **abcdefghijklmnopqrstuvwxyzß**
⟨···· **fi,ffi.1234567890 & 1234567890**

abcdefghi
jklmnopqr
stuvwxyz&

Serif versus Sans

A long-standing typographic controversy is whether serif typefaces are better communicators than sans serif ones. One faction claims that serif typeface designs are more readable than sans serif styles. Another believes that sans serif faces are more versatile and have greater clarity of form than serif typefaces.

Which faction is right? Both. Then which is the better communicator, serif typefaces or sans serif ones?

Since their beginnings, sans serif typefaces have been typographic underdogs and are still criticized by many experts. The criticisms fall into two general areas. First, and most obvious, sans serif typestyles have no serifs to guide the eye across the page. This means that typefaces like Times Roman or Baskerville are generally easier to read in continuous-text copy than Helvetica or ITC Avant Garde Gothic. Second, some feel that the apparent monotone weight in many sans serif typefaces tends to tire the eyes in lengthy text composition. Serif types generally have thick and thin character strokes that add sparkle to a page of text copy and help to retain reader interest.

Despite these criticisms, sans serif types are still good communicators, primarily because of their clarity of form. Sans serif typefaces tend to have simpler and more recognizable letter shapes than their serif alternatives. Typefaces like Univers or Franklin Gothic can, therefore, be ideal choices for typography that must be legible under adverse conditions, where space is at a premium, or at very small sizes. Also, because the numbers in sans serif typefaces are usually exceptionally legible, these are often the best choices for number-intensive typography.

(Times Roman 9/12)

A long-standing typographic controversy is whether serif typefaces are better communicators than sans serif ones. One faction claims that serif typeface designs are more readable than sans serif styles. Another believes that sans serif faces are more versatile and have greater clarity of form than serif typefaces.

(Helvetica 8/12)

A long-standing typographic controversy is whether serif typefaces are better communicators than sans serif ones. One faction claims that serif typeface designs are more readable than sans serif styles. Another believes that sans serif faces are more versatile and have greater clarity of form than serif typefaces.

Cycles used in book, *Cycles*

Sumner Stone

TYPEFACES

Stone Type Foundry Inc.

Although Sumner Stone studied both mathematics and calligraphy in college, his love of letters—and his exceptional calligraphic skills—eventually led him to a job as a lettering artist at Hallmark Cards. After Hallmark, Stone moved to Sonoma, California, to open his own design studio, Alpha and Omega Press, which he ran for nine years. During this period he earned an M.A. in mathematics at California State University, where Stone was introduced to computer technology. His interest in computer graphics and computer-generated typography eventually lead to a position as director of typography and design at Autologic in California.

Typefaces Make a Difference

For his five years at Autologic, Stone tried, with little success, to convince the company's management to institute a more creative typeface development program. Even though Stone was unsuccessful in establishing a formal program, he was able to license faces from suppliers such as International Typeface Corp. and Letraset, and even squeezed in a number of well-executed typeface revivals and an original design or two.

Stone was finally able to begin to fulfill his dream of building a typeface library in 1984, when he became director of typography at Adobe Systems Inc. in California. Over the next six years Stone, and the staff of designers he hired, built the foundation and a large part of the typographic collection that is currently available from Adobe.

By the end of his sixth year at Adobe, Stone could see that his job was pretty much complete. In accom-

Stone Type Foundry logo

plishing his many tasks while at Adobe, however, Stone realized that typeface design, his first love, had taken a back seat to concerns like contract negotiation, personnel management, and corporate politics. In January 1990, Stone left Adobe and established Stone Type Foundry.

Building the Foundation

Stone usually begins a typeface design with many preliminary pencil drawings and redrawings. "This," he says, "helps me to determine the proper proportions for each letter." Stone goes on to explain, "I usually draw a few lowercase characters at an x-height of about one-and-a-half inches [4 cm], sometimes a bit smaller, and these become the foundation for the rest of the design. I begin with the lowercase because these are the letters that are used and seen most—they set the standard."

Stone creates his typefaces on a relatively simple system: a Macintosh IIci with an accelerator and extra memory. Pencil sketches are converted to electronic data with a 300-DPI scanner, and fonts are proofed on a 600-DPI printer.

For anyone just getting started in the field of typeface design, Stone says, "Make letters by some traditional method, like calligraphy, stonecutting, or punch cutting, as well as making them on a computer." As for the future of the type-design business, "there are many more people interested in type design and typography than in the recent past. I think that this bodes well for the profession. As businesses grow more familiar with the value of type design and the profession becomes a legitimized part of the design business, I think we will see it expand and flourish."

TO THOSE
WHO FIND DELIGHT IN THE
CONSIDERED MANIPULATION OF
AND IN THE CONTEMPLATION
THE STUDIOUSLY PRINTED PA
TO THOSE
WHO PRACTISE WITH DEVOTIC
OR WHO HONOUR
THE PRINTER'S CALLING
TO THOSE
WHO KNOWING PERFECTION
TO BE UNATTAINABLE
ARE YET ARDENT FOR PERFECT
TO THOSE
WHO RESPECT AUTHENTICIT
AND CONTEMN COMPROMIS
THIS DOMICILE
FOR THE THOUGHTS OF
THEIR APOLOGISTS
IS DEDICATED
BY ITS ARCHITECT AND ITS BUIL

PORTER GARNETT

Cycles used in book, *Porter Garnett*

Cycles used in book, *Porter Garnett*

Specimen book for ITC Stone

Personal Experiences

In the Great San Francisco Earthquake and Fire. The One Continuous Sound. It is the Unforgettable Thing of the Disaster. Silent Misery Everywhere. Men, Women and Children Homeless, Dragging Trunks and Clothing, Hurrying to Places of Safety.

A scraping sound: a sound as of metal grinding on stone, incessant, harsh and cruel; a great cry of anguish of inanimate things – that is the unforgettable thing about the great disaster of San Francisco. Other sounds there were, it is true, there was the great surf-like roar of the fire as it licked up the city; there were the detonations of dynamite, with which a futile effort was made to stay the progress of the flames; there was the tramp of feet and the rumble of wheels; but it was a scraping sound, a sound as of metal grinding on stone, incessant, harsh and cruel, that will be remembered by all who heard it, by all whom it obsessed, when other memories of the calamity have been effaced. For three days and three nights people, evicted by the fire and without other means of transferring their belongings to a place of safety, dragged their trunks for miles through the streets. It was the sound thus made that was so terrible. It was a sound different

from any that I had ever heard; a sound that cannot be described. It had infinite variety, yet it was monotonous. It grated on one's very soul. Wherever one turned during those three days and three nights this sound was to be heard. Trunks and boxes laden with bedding were dragged over pavements smooth and rough by men and women. Some had ropes tied about their waists, others tugged with lacerated hands, their faces streaming with perspiration. The poor and the well-to-do labored side by side. In this, one of the most cosmopolitan cities of the world, Italians, Spaniards, Chinese and Japanese mingled in the throng.

Silent Misery Everywhere
There was misery detectable on all sides, but it was invariably silent. Through the whole of the disaster period I did not once hear the expression of distress. One could see poverty made poorer, even squalor and filth; but there were no outcries, no tears. All seemed to be resigned, some were stoical, some phlegmatic, many were cheerful. Chinamen swung along in pairs carrying bundles suspended from staves, their imperturbable faces betraying not a trace of fear, anxiety or other emotion. With some of these were small-foot women. They belonged

ITC Stone Serif

abcdefghijklmnopqrstuvwxyzABCDEFGHIJKLMNOPQRSTUVWXYZ
1234567890&$£%ÇØÆŒßçøϩœ(:;,.!?·""–'*/#«»)
[†‡§1234567890]

Medium Italic

Excellence in typography is the result of nothing more than an attitude. Its appeal comes from the understanding used in its planning; the designer must care. In contemporary advertising the perfect integration of design elements often demands unorthodox typography. It may require the use of compact spacing
EXCELLENCE IN TYPOGRAPHY IS THE RESULT OF NOTHING MORE THA
6/7

Excellence in typography is the result of nothing more than an attitude. Its appeal comes from the understanding used in its planning; the designer must care. In contemporary advertising the perfect integration of design elements often demands unorthodox typograph
EXCELLENCE IN TYPOGRAPHY IS THE RESULT OF NOTHING
7/8

Excellence in typography is the result of nothing more than an attitude. Its appeal comes from the understanding used in its planning; the designer must care. In contemporary a
EXCELLENCE IN TYPOGRAPHY IS THE RESULT OF NOT
8/9

Excellence in typography is the result of nothing more than an attitude. Its appeal comes from the understanding used in its planning; the designer must ca
EXCELLENCE IN TYPOGRAPHY IS THE RESULT
9/10

Excellence in typography is the result of nothing more than an attitude. Its appeal comes from the understanding used in its planning; the de
EXCELLENCE IN TYPOGRAPHY IS THE RES
10/11

Excellence in typography is the result of nothing more than an attitude. Its appeal comes from the understanding used in its pla
EXCELLENCE IN TYPOGRAPHY IS THE
11/12

Excellence in typography is the result of nothing more than an attitude. Its appeal comes from the understanding use
EXCELLENCE IN TYPOGRAPHY IS T
12/14

Excellence in typography is the result of nothing more than an attitude. Its appeal comes from the understanding used in its planning; the EXCELLENCE IN TYPOGRAPHY IS THE RES
14/15

Excellence in typography is the result of nothing more than an attitude. Its appeal comes from the understanding used in it EXCELLENCE IN TYPOGRAPHY IS TH
16/17

Excellence in typography is the result of nothing more than an attitude. Its appeal comes from the understand EXCELLENCE IN TYPOGRAPHY IS
18/19

Excellence in typography is the result of nothing more than an attitude. Its appeal comes from the u EXCELLENCE IN TYPOGRAPH
20/21

Excellence in typography is the result of nothing more t EXCELLENCE IN TYPOGR
24/25

Excellence in typography is the re EXCELLENCE IN TYPOGRAPH
36/30

Cycles used in book, *Cycles*

Bibliography

Selected One-Person Exhibitions

1995 *Cycles*. Honolulu Academy of Arts, Honolulu, Hawaii
1994 *Cycles*. International Center of Photography, New York, NY
1993 *Photographs and Installations 1988-1992*. Smith Anderson Gallery, Palo Alto, CA
1992 *Cycles*. Matsuya Department Store, Ginza, Tokyo, Japan
1991 *Judy Dater Photographs*. Stockton State College Art Gallery, Pomona, NJ
1990 Options Gallery, Odessa College, Odessa, TX
1989 *Judy Dater, New Work - Blatant Image/Silver Eye*. Pittsburgh, PA
Judy Dater, Recent Photographs. Santa Monica College, Santa Monica, CA
1988 *The Spirit of Woman. Judy Dater Photographs*. Albin O. Kuhn Library and Gallery, University of Maryland, Baltimore County, MD
Recent and Rarely Seen Photographs. *Judy Dater*. Images Gallery, Cincinnati, OH
1986 *Judy Dater*. Webster University, St. Louis, MO
Judy Dater: Twenty Years. DeSaisset Museum, University of Santa Clara, CA (Traveled)
1985 Northern Arizona University Art Gallery, Flagstaff, AZ
1984 Grapestake Gallery, San Francisco, CA
Kathleen Ewing Gallery, Washington, DC
Portraits of Disabled Artists. San Francisco, CA
Museum of Modern Art, San Francisco, CA
Yuen Lui Gallery, Seattle, WA
1983 North Carolina State University, Raleigh, NC
Idaho State, Pocatello, ID
Victor Hasselblad Aktiebolag Gallery, Gӧteborg, Sweden
University of Oregon. University Art Museum, Eugene, OR
The Photographic Center, Dallas, TX
Lone Star Photographic Workshop, Austin, TX
1982 Lightworks/Film in the Cities, St. Paul, MN
Kathleen Ewing Gallery, Washington, DC
Baker Gallery, Kansas City, MO
Burton Gallery, Toronto, Canada
Yuen Lui Gallery, Seattle, WA
Spectrum Gallery, Fresno, CA
Catskill Center for Photography, Woodstock, NY

1981 Atlanta Gallery, Atlanta, GA
Camera Obscura Gallery, Denver, CO
Orange Coast College, Costa Mesa, CA
University of North Dakota Art Gallery, Grand Forks, ND
1980 Jeb Gallery, Providence, RI
Photography Southwest Gallery, Scottsdale, AZ
1979 G. Ray Hawkins Gallery, Los Angeles, CA
Yuen Lui Gallery, Seattle, WA
Kimball Art Center, Park City, UT
Contemporary Art Center, New Orleans, LA
1978 Witkin Gallery, New York, NY
1977 Grapestake Gallery, San Francisco, CA
Susan Spiritus Gallery, Newport Beach, CA
1976 Evergreen State College, Olympia, WA
1975 Spectrum Gallery, Tucson, AZ
Silver Image Gallery, Seattle, WA
1974 Oakland Museum, Oakland, CA
1973 University of Colorado, Boulder, CO
Center for Photographic Studies, Louisville, KY
1972 University of Maryland, Baltimore, MD
Witkin Gallery, New York, NY
1965 Aardvark Gallery, San Francisco, CA

Selected Two-Person Exhibitions

With Imogen Cunningham:
1986 Gallery of Contemporary Art, University of Colorado, Colorado Springs, CO
With Gail Skoff:
1982 *Girls of the Golden West*. Santa Fe Center for Photography, Santa Fe, NM
With Jack Welpott:
1976 Galerie Fiolet, Amsterdam, The Netherlands
University of Tokyo Gallery, Tokyo, Japan
Musée Réattu, Arles, France
Enjay Gallery, Boston, MA
1975 Shadai Gallery, Tokyo, Japan
Washington Gallery of Photography, Washington, DC
1974 Witkin Gallery, New York, NY
1973 George Eastman House, Rochester, NY
Focus Gallery, San Francisco, CA
Image Works Gallery, Cambridge, MA
Ohio Silver Gallery, Los Angeles, CA

149

Cycles used in book, *Cycles*

A Conspectus of Type Design
From 1454 to the Present Day
Compiled by Porter Garnett
Printed at The Laboratory Press
Carnegie Institute of Technology, Pittsburgh, Pennsylvania, 1935 *

Note

In compiling this conspectus, the chief authorities consulted were: Audin, Beaujon (Mrs. Warde), De Vinne, Enschedé, Fournier, Haebler, Johnson, McKerrow, Mores, Morison, Thibaudeau, and Updike. A number of works dealing with specific periods, printers, or type-designers have also been helpful.

A word of explanation is necessary regarding the dates given. Although, in most instances, they represent the first appearance of a new type, in some they indicate either the beginning of a designer's active career or a year within the period of his activity accepted as representing some contribution of major importance. When dates, as given by various commentators, differ, those that seem to be supported by the best evidence have been used.

Specimens – Of the types referred to in this Conspectus, the seventy-five, to which numbers have been attached, will be illustrated on the right-hand pages.

I. THE INVENTION – FIRST GOTHICS
The first types used by Gutenberg (those of the 1454 Indulgence) were of the style now called "gothic" to distinguish it from the later "roman," and showed two distinct forms, a "pointed gothic"

**This book was carried to page proofs but not published. Bracketed numbers refer to type illustrations that were never included. – Ed.*

128

Book design using Arepo for headings and Cycles for text

ITC Stone ITC Stone ITC Stone

ITC Stone Specimen

FACING EDEN
100 Years of Landscape Art in the Bay Area

Steven A. Nash

with contributions by
Bill Berkson, Nancy Boas, Michael R. Corbett, Patricia Junker,
Constance Lewallen, Ellen Manchester, and Marc Simpson

print

72 point Times Roman

TYPEFACES

print

72 point Century Old Style

Stone Print

print

72 point Print

ore consigned

e suspect, will

ed to get lost

l insights that

ont, but they'v

hey come to y

ted to herald

F.O.B. (for fro

ings in the vis

be found, no

Created for *Print* magazine, Stone Print's design was heavily influenced by technology. Typefaces created expressly for publication design are some of the most difficult challenges a type designer can face. They must be inviting, easy to read, and space-efficient. According to Stone, the real trick is to make the visual rhythm soothing rather than irritating—an important priority for a truly readable type.

As design criteria, the magazine stipulated that the face should allow for high character counts without the text blocks looking too dense, and a design that works well in a range of sizes and line lengths. To add to Stone's burden, it was also suggested that Times Roman and Century Old Style, the typeface *Print* had been using for the last ten years, be used as a basis of comparison.

Frequent tests of the typeface set in blocks of text copy were a vital part of the design process. "We read by looking at word shapes rather than individual letters," Stone points out. "This makes the overall characteristics of a typeface more important than the individual beauty of a single letter."

While design of the accompanying italic face proved difficult, Stone was able to successfully establish both designs and offer up a final product whose purpose serves the reader as well as the designer's eye.

Print used in *Print* magazine

he renowned Stan Mack, giving his own wry take

s called "Between the Lines."

ou'll note that we're still running in-depth pieces

gish side, but kept as focused and pointed a pe

PRINT Transformed: *A Note to Our Readers*

Welcome to the new *PRINT*. New size. New format. Same purpose: to provide the most thorough-going, wide-ranging coverage of the graphic design field that you'll find anywhere—the kind of coverage that has built our reputation and earned us four National Magazine Award nominations in a row, including the Award for General Excellence in 1994. But our redesign has given us the opportunity to revitalize that coverage, to sharpen and improve it. So be assured—our new look notwithstanding, we're still the *PRINT* you know and respect, except we think we're even better.

The most striking editorial/layout change is right here in front of the book. Starting with this issue, most of our departments, heretofore consigned to the the back, will appear as soon as you open the magazine. This prominence, we suspect, will be favored by our readers, some of whom have told us that our departments seemed to get lost in back. Well, we're very proud of our departments, which are full of opinions and insights that generate a lot of interest, even controversy, so not only have they been moved up front, but they've been made more visible with redesigned formats. You don't have to go to them; they come to you.

Speaking of departments, we're delighted to herald the appearance of two new ones. The first can be found by turning the page. Called F.O.B. (for front of book), it's a collage of notes and comments and mini-essays on various happenings in the visual and media environment, both here and abroad. The second new department can be found, not here in front, but on the very last editorial page of the issue. It's a cartoon strip by the renowned Stan Mack, giving his own wry take on the world of design and communication. It's called "Between the Lines."

Turning to this issue's feature articles, you'll note that we're still running in-depth pieces on important topics, some of them on the longish side, but kept as focused and pointed as possible. These are supplemented with short articles that deal more glancingly, but just as tellingly, with their subjects. You'll also note a better balance between pieces that are text-heavy and those that are primarily visual. One brand new feature, Center Spread, is *all* visual. Our aim with these changes and additions is to achieve more impact, variety, and immediacy.

This objective will be much aided by the magazine's redesign, which is geared toward maximum flexibility. A four-column grid (as opposed to our former three-column grid) allows for quite small and large pictures to appear on a page together, enabling us to create very dramatic pages with lots of contrast. The body type is still Stone Print, which was designed especially for *PRINT* by Sumner Stone, but it's not as condensed. The caption type, also designed by Stone, is Silica, and replaces the previous Helvetica.

In sum, we've done a number of things to make the magazine more pertinent than ever to your needs and interests, as well as more purely pleasurable and even surprising. You, of course, will be the judge of how well we've succeeded. We welcome your comments.—*The Editors*

4PRINT

Print used in *Print* magazine

abcdefghi
klmnopq
rstuvwxyz

Stone Print Italic specimen

Arepo

Arepo was drawn as a display version of Stone Print, intended for use at large size. The letters were drawn with pencil at 200 points, based on the Stone Print forms. The proportions of the roman letters are almost exactly the same as those of the Print design.

Arepo was also influenced by two other projects Stone had worked on: ITC Bodoni and Trajan. "Both of these influences," says Stone, "had an effect on the thinking about Arepo, and also to some extent in the final forms of the letters." With these influences in mind, Stone also drew a companion set of swash letters to accompany Arepo's basic set of italic characters.

Stone looks on Arepo as his most successful translation of drawings into a font of type. "I measured nothing in the drawing or the digitization process," he says. "I wanted to try to preserve the subtlety and liveliness of the letterforms as they were translated into type. And the name? Being a lover of opera, Stone wanted to call the face Opera, but found that name already taken. So, he reversed the word and got the next best alternative.

Arepo and Cycles used in book, *Facing Eden*

Contents

Facing Eden table of contents

A B C D E F G H I

Celebrating Possibilities and Confronting Limits: Painting of the 1930s and 1940s

Patricia Junker

Certainly California is a Paradise. . . . In a sense, together with all its joys, that is the defect that California presents, because paradise is an impossibility for men to construct on earth, and the Californian is no exception to the rule. Furthermore, the excellences of Paradise are in the long run deficiencies in the "real world," which is of necessity constituted of possibilities and limitations, facilities and difficulties, urgency and constraint. To live in this world means to be always between the swordpoint and the wall, to have to make the right choice with every moment, to have infinite resources at one's disposition but a counted number of days, to live and to die.

Julián Marías

If ever a place can be said to represent the ultimate irony of human existence, it is the San Francisco Bay Area, a landscape of surpassing physical beauty, natural bounty, and ease of living – ample virtues that serve to remind us of the short time we have on earth to embrace them. It is a place where visions of possibility are tempered by a keen sense of human limitation. By geological accident, inhabitable space is confined to discrete land masses, each bounded by the bay or one of its inlets; it is a circumscribed world of human beings and nature. The blessings of a mild climate and a long growing season are checked by the difficulty of securing and maintaining arable land. And that urgency to meet the ever-expanding needs of modern urban society is constrained by recognition that this ever-shifting landscape is fundamentally at odds with the building of cities.

Although the inhabitants of the Bay Area were awakened to these ironies in 1906 at the time of the devastating earthquake and fire, it took the cataclysmic events of the Great Depression to give them human face and form – to present us with clear images of aspiration and failure, hope and despair, which have remained a part of our vision of California. In Bay Area landscape art of the 1930s and '40s, it is the human element that gives the region its distinctive shape, color, texture, and meaning. During this period, the city and the cultivated landscape took on new meaning to artists. For some, human intrusion lent to the local scene a unique kind of plastic rhythm, and they delighted in its contours – in the geometric edge of the modern city, in the

61

dynamic pattern of land and water masses. Landscape served a developing formalism, and it was favored as a vehicle of revelation and artistic invention. For others, however, the inescapable shoreline that is the distinctive feature of this region suggested more than just formal tension – it became the focus for ruminations on the social and psychological consequences of living within a delimited space.

The Landscape of Possibility

Considering the state of the regional landscape school in 1932, *Los Angeles Times* critic Arthur Millier observed: *In California . . . we still have the group of mature painters who deal with our landscape. Untroubled by the age of speed and change they continue to interpret nature in terms of light and atmosphere. A younger element which has grown up here evinces more interest in what man has done to the landscape. They begin to see the forms, cities, and people as art material.*

Millier's "younger element" is exemplified in San Francisco by a small group of forward-thinking artists who, through the decade of the '20s, expanded the concept of landscape painting in the Bay Area. Their new focus on the cultivated landscape and urban life may be explained in part by their deep roots in the region and their awareness of how the human presence had shaped the state's landscape during the first decades of the twentieth century. Otis Oldfield, Rinaldo Cuneo, and Charles Stafford Duncan – among the most innovative and expressive painters of the local scene by the middle of the decade – were all raised in or around San Francisco, and their lives were shaped by an essentially urban experience. A closely knit group, with their studios clustered, at least initially, on Montgomery Street, they shared as well a synthetic vision that had been conditioned by keen interest in and assimilation of French modernist painting. Having experimented with postimpressionist color and the radically distilled cubist forms and condensed space, they brought to landscape painting a new sense of design – a keen eye for the essential patterns and colors of the kaleidoscopic world around them. That world was distinctly modern, undeniably American, and uniquely Californian; it was, moreover, emphatically human-centered.

Arepo used in book, *Facing Eden*

Stone Type Foundry

Stone Type Foundry Inc. was started by Sumner Stone in 1990. It is dedicated to designing and producing typefaces for professional typographers. The Foundry also does custom typeface design and production. The typefaces shown in this catalogue were designed by Mr. Stone.

Character Sets

Standard

ABCDEFGHIJKLMNOPQRSTUVWXYZÆŒØ
abcdefghijklmnopqrstuvwxyz&æœøfiflß
ÀÁÂÃÄÅ ÈÉÊË ÌÍÎÏ ÒÓÔÕÖ ÙÚÛÜ ÑÇŸ
àáâãäå èéêë ìíîï òóôõö ùúûü ñçÿ /IV…_
1234567890$¢ƒ£¥%‰#@*'"^~·<>¬=÷+µ©™®#°
-- — .,:;?!¿¡""''„,«»‹›[]{}() †‡¶§•*`´˜¯˘˙¨˚¸˝˛ˇ

Old Style Figures

ABCDEFGHIJKLMNOPQRSTUVWXYZÆŒØ
abcdefghijklmnopqrstuvwxyz&æœøfiflß
ÀÁÂÃÄÅ ÈÉÊË ÌÍÎÏ ÒÓÔÕÖ ÙÚÛÜ ÑÇŸ
àáâãäå èéêë ìíîï òóôõö ùúûü ñçÿ /IV…_
1234567890$¢ƒ£¥%‰#@*'"^~·<>¬=÷+µ©™®#°
-- — .,:;?!¿¡""''„,«»‹›[]{}() †‡¶§•*`´˜¯˘˙¨˚¸˝˛ˇ

SMALL CAPITALS

ABCDEFGHIJKLMNOPQRSTUVWXYZÆŒØ
ABCDEFGHIJKLMNOPQRSTUVWXYZ&ÆŒØFIFLSS
ÀÁÂÃÄÅ ÈÉÊË ÌÍÎÏ ÒÓÔÕÖ ÙÚÛÜ ÑÇŸ /IV…_
1234567890$¢ƒ£¥%‰#*'"^~·<>¬=÷+µ©™®#°
-- — .,:;?!¿¡""''„,«»‹›[]{}() †‡¶§•*`´˜¯˘˙¨˚¸˝˛ˇ

FRACTIONS

1234567890¹²³⁴⁵⁶⁷⁸⁹⁰/₁₂₃₄₅₆₇₈₉₀1234567890

ABCDEFGHIJKLM
NOPQRSTUVWXYZ
abcdefghijklm
nopqrstuvwxyz
&[.,:;?'‘-
1234567890
1234567890

Arepo Roman 18 pt

AABBCDDEEFFGG
HHIIJJKKLLMMNN
OPPQQRRSTTUVV
WWXXYYZZ
abbcdefghhijkkllm
noppqqrstuvwxyzz
&[.,:;?'‘-
1234567890

Arepo Italic with Swash Capitals 18 pt

ABCDEFGHIJKLM
NOPQRSTUVWXYZ
abcdefghijklm
nopqrstuvwxyz
&[.,:;?'‘-
1234567890

Arepo Bold 18 pt

AREPO

Arepo specimen

KLMNOPQ

Custom Typeface Designs

There is nothing new about the idea of custom-designed fonts for a publication or project. The first font, by Gutenberg, was created especially for a version of the Bible. The typeface we know as Bembo was commissioned by Aldus Manutius for a book he published in the late fifteenth century. William Caslon's first typeface was the result of a commission, and Giambattista Bodoni regularly created new type-faces for specific projects.

The current explosion in custom typeface designs created for publications can probably be traced to Roger Black, the prolific and exceptionally creative magazine designer. Not only is Black a consummate graphic designer, he is also a type enthu-siast of the first order. Black's first important job as an art director was for *Rolling Stone* magazine, where, as part of his redesign of the publication, he commissioned a new typeface to be used exclusively by the magazine. Black has, in the past twenty-five years, rebuilt some of the world's most prestigious magazines and newspapers, and more often than not a custom-designed typeface was part of the project.

Today, because technology has democratized typography and type design, more and more publications are commissioning custom typefaces for their use—so much so that most independent typeface designers are doing more custom work than pro-ducing designs on spec for retail sales. Many will say that the retail designs are important to keep their name and work in the public eye, but it is the custom type-face designs that pay the bills.

Bembo
Caslon
Bodoni

M
VANZETTI
MANUSCRIPTS
NEW YORK

DESIGNER

CAROL TWOMBLY

There are no born type designers; most enter the profession through a circuitous series of events. Carol Twombly is no exception. "I thought I wanted to become a sculptor, so when it was time for college, I followed my architect brother to the Rhode Island School of Design," she recalls. Once there, however, Twombly drifted from three-dimensional art to the two-dimensional variety. "I discovered that the communication of ideas by positioning black shapes on a white page offered a welcome balance between freedom and structure. Graphic design seemed a more practical choice for me."

In the summer of her junior year at RISD, Twombly's typography professor, Charles Bigelow, asked her to assist him in the production of typeface designs for a German digital type foundry. Twombly was gaining a respect for letterforms through Bigelow's typography courses, but when she began working at his studio she came to understand the subtle and involved process of designing a typeface. From this point on, type design became the focus of Twombly's study. From RISD, Twombly went on to earn a master of science degree in digital typography

digitizing Lithos from sketch

Alegria typeface

verdadera
En cinta **All around**
claridad
olvido
Alegría
TIEMPO
clarity
Como una espiga mas

TRAJAN

Trajan typeface

from Stanford University—one of only five people to hold this specialized diploma combining the art of graphics and the science of computers.

Shortly after she earned this degree, Twombly completed Mirarae, her first typeface. "I had had enough of trying to understand computer science, and I went back and started drawing letters—they turned into the Mirarae typeface. I entered the design into the Morisawa [Japan's largest type foundry] competition just for fun. I was amazed when a very friendly Japanese gentleman called me up one day to tell me I had won first prize in the Latin text division. I could not believe it—I was overwhelmed; that was my first typeface design. So I thought, 'Hmm, maybe there's something to this.'"

New Tools at Adobe

In 1988, Twombly joined Adobe Systems Inc. as one of three in-house type designers. It was at Adobe that she first began using the Macintosh and Mac applications to design type.

Today, Twombly begins her type designs with pencil and paper, and then uses FontStudio to digitize her drawings. Although FontStudio is no longer commercially available and end-user support is nonexistent, Twombly prefers this design tool to the more common Macromedia Fontographer. "Sure, it crashes a lot, and I have to back up my files like crazy, but I like the drawing interface; it's simple and elegant. And the letter spacing tool gives me more control than Fontographer."

When the design is fairly far along, Twombly transfers the data to a Sun workstation running

Adobe's proprietary FontEditor software. Here, she fine-tunes the letter shapes and their spacing. Sometimes, however, when she is having trouble getting the letter shapes to look just the way she wants, Twombly will return to paper and pencil to refine her work. "The Bézier curves of Adobe Illustrator and FontStudio can be very symmetrical and dull. The shapes I draw by hand are more organic and unpredictable and therefore more lively. Once I know what I want, I can recreate the shapes using the Bézier curves on the screen."

Twombly enjoys creating display faces the most. "Text families have so many characters and require such attention to detail. They can be both tedious and exhausting to create. I like display designs better," says Twombly. "They're more spontaneous and fun to work on."

CHARLEMAGNE

Carolingian capitals were originally used for titles, to contrast with and enliven text. The typeface that Carol Twombly of the Adobe type staff has designed, Charlemagne, can be effective in the same role in today's book typography. It is useful as well in other display uses, especially when the design calls for a more adventuresome or dynamic quality than conventional Roman capitals provide.

The Charlemagne typeface was inspired by capitals such as those found in the tenth-century Carolingian manuscript, *The Benedictional of St. Aethelwold.* Twombly began this design by sketching a handful of letters whose generous bowls, swelling stems, and accentuated serifs captured the exuberance of the manuscript's title lettering. Twombly scanned these drawings into Adobe's computer system, which enabled her to make the many adjustments necessary to fine type design directly on the computer screen. After completing the regular-weight design, Twombly carefully modified it on-screen to create the bold weight.

Charlemagne regular and bold were designed for use in posters, book titles, packaging, and other display applications; the letters look their best at 18 points and larger. For the best results, care should be taken to optically letterspace any job that is typeset in a titling (all-capital) typeface.

Top right: letterforms from "The Benedictional of St. Aethelwold," 960-980 A.D. (Episcopal liturgical blessings). Photo courtesy of the British Library, London. Bottom right: Carol Twombly's pencil sketches for Charlemagne. Letterforms are 96-point Charlemagne regular.

Charlemagne typeface

Test output of Chaparral

Reason, Types
Grand: Irving
Erik Spieker

who know not must learn: soon enough, knowledge and
UP A NEW AND exciting world, replete with objects of
nplation. THERE ARE MANY ways to bake a parrot. And a

say in Berlin, there are many ways to bake and
t. And the fact that there are thousands of ways
ign, say, a small "a"ONCE WE DECIDE AREN
obvious to the expert reader OREGANO SAUSE.

ten difficult, of not impossible, to convince as
raphic innocents that it makes sense to spend
UCH TIME and – let's admit it – love drawing
little letters WHICH, SO OFTEN, end their lives

As we say in Berlin, there are *many ways to bake* a parrot. And the
fact that there are *thousands of ways* to design, say, a smaller "a
will be *obvious to the expert* reader of these lines. But it's so
often difficult, *if not impossible,* to convince typographi

ticed and crumpled in a waste-paper basket.
at any rate, is how the novice might see it.
INITIATE, though, is sensitive to the differ-
between typefaces, APPRECIATES THE effect

differences on the reader. And, after all,
typography just like the other arts? Those
know not must learn: SOON ENOUGH the
ledge opens up a new AN EXCITING world,

innocents that it *makes sense to* spend so much time a
and – *let's admit it* – love on drawing those little let-
ters which, so often, *end their lives* as litter, was
unnoticed *and crumpled* in a waste-paper bas

question is: who is to open the eyes of
are to typography's secret GARDEN?*
I want to know, there NO TYPE critics?

ket. This, *at any rate,* is how the novice m
ght see it. The *initiate,* though, is sensi-
tive to the differences *between* types
faces, and *appreciates* the effect o

y morning the papers tell me about a
ight's events: THEATRE, FILM, and
television, all get critical ATTENTION.

ll-time architectural critics. Let us
exercise OUR EYES for a moment in
UILDINGS IN our cities: critics don't

these *differences* on the read
er. And, *after all,* isn't typo
graphy just like the othe
arts? Those *who are* no

tly turn the tide of architectural
re, do they? PERHAPS limit and
HITECTURAL critic illustrate tains

g in the critical trade: fine words
er no parsnips. Criticism alterna-
always APPEAR AFTER there is
en CONCRETE has set: wear can't

patient, and wait until prema-
wear of the materials leads to a
rrival of the DEMOLITION an
, having drawn ATTENTION and

in our visual culture, I notice
we still haven't gotten to the
t the chapter. YOU BEGAN, is
ingle letter. It RAISES yet anot

Botanical · Boredom

stion (which is not the be) is
ession it may first appear to
WHAT KIND of world would
URE HAD produced a family?

Carol Twombly

LITHOS

Making Lithos bold from medium

Of the three typefaces Twombly created for Adobe, Lithos perhaps is the most enduring of the three. Lithos is a monoline sans serif face based on fifth-century B.C. Greek inscriptions, (*lithos* means stone in Greek). "I was attracted by the simple, elegant shapes of these carved letters," explains Twombly. "I began by drawing fairly geometric interpretations of them. I didn't copy letters directly, however; I started with fairly close copies of the Greek stuff, but the letters ended up looking a little bit dead on the page. I also wanted to make the design a bit more contemporary but not lose the simplicity of the original Greek model."

Twombly drew the lightest, middle, and heaviest of the five weights then used the interpolation capabilities of computer software to help her create the weights between these. As for the black weight, Twombly remembers "I wanted to make it as heavy as I could and still maintain the openness of the forms. I discovered that the diagonal stroke endings became the major focus of the design.

Lithos samples

THE SKELETON SHAPES OF THE LETTERS ALPHABET CHANGE HARDLY AT ALL WH SKILLED TYPE DESIGNERS DEVOTE SO M SOMETIMES THEIR WHOLE LIVES, TO DR DIFFERENT VERSIONS OF THE OUTLINES FRENCH DESIGNER ROGER EXCOFFON L BASIC LETTER TO & ROAD, AND THE DES TO DRIVERS, EACH OF WHOM STEERS A DIFFERENT ROUTE ALONG IT. BUT THIS DOES NOT EXPLAIN WHY THESE DRIVER THE GERMAN CALLIGRAPHER AND TYPE WROTE: 'THE MAKING OF LETTERS IN EV IS FOR ME THE PUREST AND THE GREAT AND AT MANY STAGES OF MY LIFE IT W WHAT A SONG IS TO THE SINGER, A PIC THE PAINTER, A SHOUT TO THE ELATED SIGH TO THE OPPRESSED - IT WAS AND THE MOST HAPPY AND PERFECT EXPRES LIFE.' BY NO MEANS ALL THE DESIGNER IN THIS BOOK OPERATED AT THIS LEVEL

Lithos drawings

HAMBURGEVONS
HAMBURGEVONS
HAMBURGEVONS
HAMBURGEVONS
HAMBURGEVONS
HAMBURGEVONS
HAMBURGEVONS
HAMBURGEVONS
HAMBURGEVONS
HAMBURGEVONS

Lithos sample

Lithos sketches

Ancient Greek inscriptions

Adobe Caslon

TYPEFACES

With Adobe Caslon, her fourth design for Adobe, Twombly proves that she is also perfectly capable of creating sensitive, well-drawn text typefaces.

Translating the first Caslon's strong, typographic personality into the unerring, cool perfection of a digital font proved to be a serious challenge for Twombly. Making the challenge even more arduous was the fact that there was no single Caslon design to use as a model. "Trying to come up with one design that could be successfully scaled to different sizes was very difficult," confesses Twombly. The metal type had been hand-cut, and each size was quite different from the next.

For inspiration, Twombly focused her study directly on the source. "I looked at a number of books printed in original Caslon types from the late 1700s," she explained, "including an original type specimen sheet printed by Caslon himself in 1738." Studying these original type specimens with the aid of a microscope, Twombly was able to get a hint of the shapes of the Caslon type as they had been impressed on the paper. "I aimed for something in between these two extremes to arrive at a design suited to today's offset printing technology."

Adobe Caslon

Caslon samples

!"#$%&'()*+,-./
0123456789:;<=
>?@ABCDEF
GHIJKLMNO
PQRSTUVWX
YZ[\]^_'abcdef
ghijklmnopqrst
uvwxyz{|}~¢£/
¥ƒ§¤'"«‹›fifl—†‡
¶•„""».‰¿123456
789

Linotype v.48.3

Caslon near-final sketches

Caslon patterns

aaa bbb

aaa bbb

aaa bbb

Adobe Caslon sketches

The First Caslon

Surviving 270 years of typographic trends, technology changes, and font fads, Caslon has earned its title of the oldest living typeface. Faces like Garamond or Jenson predate Caslon, but all that is available today are reproductions of these early designs. Caslon is a different story. The original punches, hand-cut by William Caslon, are still intact and could be used to produce new matrices and fonts that are identical to those used to set type in the early eighteenth century.

Caslon, like Times Roman, Jenson, and Plantin is classified as a Dutch Oldstyle type design. As the name implies, Dutch Oldstyles originated in Holland. For much of the seventeenth century, Holland was a major typographic center, producing type for northern Europe and England. These Dutch types were not like the delicate French Oldstyles, which preceded them in popularity. They were sturdy designs, with strong, heavily bracketed serifs and comparatively large x-heights. Dutch Oldstyles are ideally suited to what was called job work.

Not only is Caslon old, it also has staying power. Except for a few years at the end of the last century and the last couple of decades, Caslon has consistently been the typeface of choice among printers and typographers. It has been used to set nearly every form of printed material from fine books to high-pressure advertising and the most mundane ephemera. Caslon has even been the choice of celebrities. It was the favorite typeface of Benjamin Franklin and was used to set both the Declaration of Independence and the United States Constitution. British author and playwright George Bernard Shaw, also insisted that all his work be typeset in Caslon.

Original Caslon specimen

Making Typefaces Legible

Typographic clarity comes in two flavors: legibility and readability. Even though much of the typographic community treats these two terms as interchangeable, they are not. Different typefaces have varying degrees of legibility, while all typography should be readable.

Legibility is generally considered to be the degree of ease with which one letter can be distinguished from another in a particular typeface design. Readability, on the other hand, is the degree of ease with which typography can be read.

Typeface legibility is something that is ultimately controlled by typeface designers. The most legible typefaces are those that tend to be transparent to the reader. That is, they present the information in a clear, concise manner and call no attention to themselves. Highly legible typefaces are those like Century Schoolbook, Adobe Garamond, or Univers.

Generally, the most legible typefaces are those that offer big features and have restrained design characteristics. While these attributes may seem contradictory, actually they're not. "Big features" refers to things like large, open counters, ample lowercase x-heights, and character shapes that are obvious and easy to recognize. The most legible typefaces are also restrained, in that they are not excessively light or bold; weight changes within characters are subtle; and if serifs are present, they are not overly elongated, very thin, or extremely heavy.

Open counters help to define characters. It is believed that the additional white space within certain letters such as "o," "e," and "c" helps to influence their recognition. A byproduct of such open counters is usually a large x-height. As long as it's not excessively large, this can also tend to improve typeface legibility.

Over 95 percent of the letters we read are lowercase composition. Within sensible limits, the larger the proportions of the lowercase characters, the more legible type letters are. Taken to the extreme, however, the opposite effect can result. Typefaces with an excessively large x-height suffer in legibility because their ascenders and descenders begin to lose their definition. Lowercase "h"s begin to look like "n"s, "d"s and "q"s like "a"s, and "i"s like "l"s. Also, the white space that surrounds a character and begins to define it is reduced as the x-height increases. In addition, when the various lowercase letters are combined into a word, the ascenders, descenders, and x-height characters create an overall outline shape that is stored in the reader's mind and serves as an identifier when the word is seen again. As the x-height of a typeface begins to increase beyond a

Century
Schoolbook

Adobe
Garamond

Univers

a *Baskerville*

a *Franklin Gothic*

a *Futura*

g *Baskerville*

g *Helvetica*

g *Futura*

reasonable point, the outline shapes of words set in it become less defined. Typefaces like Antique Olive, while popular (and just within acceptable design limitations for display typography), are usually outside the realm of good text typography.

Individual letter shapes can also affect typeface legibility. Ideally, letters should be distinctive and easy to recognize. For example, the two-storied "a" like those found in Baskerville or Franklin Gothic is much more legible than the single-storied "a" found in Futura or Revue. The lowercase "g" based on roman letter shapes is more legible than the simple "g" found in Helvetica or Rockwell. Letters of high legibility are the lowercase "d," "m," "p," "q," "w," and virtually all the capitals. Low-legibility letters are "c," "e," "i," "n," and "l." Sans serif typefaces generally tend to be slightly more legible than serif designs; their shapes are simpler. This is why many children's first books are set in modified sans serif designs. In the early stages of learning to read, children read individual letters rather than the words or groups of words that the proficient reader sees.

Typefaces that are very bold or exceptionally light tend to rate low on the legibility scale. It has been found that optimal character stroke thickness is about 18% of the letters' x-height. Typeface weights like Apolline Regular or Times New Roman Medium fall into this general category. As for departures from the norm, lighter faces tend to be more legible than heavier weights of type. They enable full, open counters and unmodified character shapes. Many bold and black designs become only caricatures of the original designs, with very small counters and drastically modified letter shapes. Gill Kayo is a perfect example—it is lots of fun and commands attention in a headline, but it severely taxes our ability to differentiate character shapes.

In serif typefaces, individual letter legibility begins to suffer as serifs take on exaggerated shapes. Very long serifs, or those that are exceptionally heavy, detract from individual letter legibility, as do those with unusual or highly modified shapes.

Ideal serifs are somewhat short, slightly bracketed, and heavy enough to be obvious but not very obtrusive. ITC Novarese and Plantin have perfect serifs.

Graphic designers have no control over typeface legibility. Typeface designers do have that control. While not all typefaces should be designed to be paragons of legibility, those that are intended to be used for text or lengthy display composition should be drawn with the above guidelines in mind—otherwise you are not creating tools that will give the expected results.

Apolline

Times Roman

Antique Olive

Plantin

Gill Kayo

Special-Purpose Fonts

Franklin Gothic

Franklin Gothic Franklin Gothic

Franklin Gothic Franklin Gothic Franklin Gothic Franklin Gothic

Franklin Gothic Franklin Gothic Franklin Gothic Franklin Gothic Franklin Gothic Franklin Gothic Franklin Gothic Franklin Gothic

Franklin Gothic Franklin Gothic Franklin Gothic Franklin Gothic Franklin Gothic Franklin Gothic Franklin Gothic Franklin Gothic

Franklin Gothic Franklin Gothic Franklin Gothic Franklin Gothic Franklin Gothic Franklin Gothic Franklin Gothic Franklin Gothic

Franklin Gothic Franklin Gothic Franklin Gothic Franklin Gothic Franklin Gothic Franklin Gothic Franklin Gothic Franklin Gothic

Franklin Gothic Franklin Gothic Franklin Gothic Franklin Gothic Franklin Gothic Franklin Gothic Franklin Gothic Franklin Gothic

Needle-nose pliers were developed to grab and hold onto things in places too small for regular pliers, and hacksaws were invented to cut metal and other hard materials. Like hand tools, many typefaces have been also been designed to fulfill special purposes. Some were created to work best in small sizes, others were drawn to be space-efficient, and others are especially legible.

Fonts for Little Sizes

Whether it's that legal stuff that big companies seem to require at the bottom of their ads, copy for classifieds in newspapers and periodicals, figure captions, or dosage directions on medicine bottles, there are times when text type cannot be set at the optimum sizes (above 10-point). Sometimes they're called "mouse type," "lawyer fonts," or "flyspecks," but when normal sizes are too big, special fonts should be used to set type in small sizes.

Light- to medium-weight faces work best, because their counters are not prone to filling in. Sans serif faces also work well, because their individual character shapes tend to be more legible. Typefaces with a large x-height are also easier to read at little sizes.

Big Type

When graphic designers are using type big, they're doing so for a reason—usually to attract attention. Bold, brassy fonts are what's called for. Oh, sure, some delicate typefaces will work fine at large sizes—ITC's Bodoni 72, for example, is beautiful at large sizes—but big sizes of type cry out for fonts that are robust, distinctive—maybe even a little audacious.

ASPHALT BLACK

News Gothic Condensed

Faces that look good in big sizes are Asphalt Black and Citadel Solid from the Creative Alliance, ITC's True Grit and Motter Corpus, Aachen from Letraset, and Copal from Adobe. Script typefaces can also be big and bold; just look at Mistral or Bendigo, both available as Fontek fonts from Letraset.

Fonts That Save Space

Sometimes designers have lots to say, and not very much room in which to say it. Whether it's the financial pages of an annual report, a directory of product names and inventory numbers, or just a newsletter sidebar with more copy than will fit, many times the usual font choices are too extravagant with space. It's at times like these that faces with condensed proportions are best choice.

While the marvels of digital technology enable you to easily condense regular fonts to skinny proportions with just a few mouse clicks, don't succumb to the temptation. Electronically distorted type ruins character stroke weights and creates unattractive and often illegible typography.

Type Timeline

Fifth century B.C.

Greek lapidary type
One of the first formal uses of Western letterforms, this type was adapted by the Greeks from the Phoenician alphabet for their own needs; they changed several of the letters and created the foundation for Western writing.

Second century B.C.

Roman lapidary type
These letterforms showed the transition from ancient Greek to the more modern Roman shapes and proportions.

First century B.C.

Roman monumental capitals
These were the foundation for Western type design and the ancestor of all serif typefaces.

Fourth and fifth centuries

Square capitals
These formal hand-written letters evolved from Roman monumental capitals.

Eighth–eleventh centuries

Carolingian minuscule
Thanks to Charlemagne, this became the basis for the standard lowercase alphabet.

Fourteenth century

JOHANNES GUTENBERG
(1394–1468)
Although he did not invent movable type, the printing press, or printing ink, and he wasn't even the first person to print with metal type, Gutenberg did invent the art of typography. Gutenberg's contribution was in taking all these existing devices and synthesizing them into an economical and practical product. The adjustable mold, which Gutenberg did invent, enabled one model of a letterform produced by a designer, to be replicated thousands of times.

Fifteenth century

NICOLAS JENSON (1420–1480)
Jenson was one of the first printers to cut and use fonts based on Roman, rather than northern European or fraktur letterforms. Revivals of his type include William Morris' Golden Type and the very successful Jenson Oldstyle first released by American Type Founders in 1893.

WILLIAM CAXTON (1421–1491)
Generally credited with introducing the craft of printing with movable type to England, he also printed one of the first commercial advertisements, a poster extolling the products and services of his print shop.

1450
The Gutenberg Bible was printed—the birth of the art of typography.

ALDUS MANUTIUS (1450–1515)
The great Italian printer and type founder commissioned Francesco Griffo to design several faces, the most important of which is now revived under the name Bembo. The basis for this face was first used in Pietro Bembo's *De Aetna*, printed by Manutius in a font designed by Griffo. It is interesting to note that Griffo only designed a lowercase for the project, with the caps being pulled from an existing font. Manutius is generally credited with the invention of italic type as a means to produce inexpensive books; the former is true, but not the latter—Manutius never produced an inexpensive book in his life. Italic type was created as a marketing tool to help sell his books to well-off scholars and government officials who wrote in a similar style.

1476
Caxton set up his printing business in the Almonry of Westminster Abbey.

Sixteenth century

CLAUDE GARAMOND (1500–1567)
Garamond was the first designer to create faces, cut punches, and then sell the type produced from the punches.
Unfortunately, even though many bought and used his fonts, Garamond had little lasting success in this business. In fact, when he died he owned little more than his punches, and shortly after his death his widow was forced to sell even these. Thus began the time-honored tradition of type designers creating beautiful tools for others to use profitably. On the plus side, Garamond was the most distinguished type designer of his time, perhaps of the entire Renaissance. A true typographic innovator, he was instrumental in the adoption of roman typeface designs in France as a replacement for the commonly used gothic, or blackletter, fonts. He was one of the first type designers to create obliqued capitals to complement an italic lowercase.

ROBERT GRANJON (1513–1589)
Active from 1545 to 1589, Robert Granjon provided the models for both Plantin and Times New Roman, as well as Matthew Carter's Galliard. The face that bears his name, however, is based on a design by Claude Garamond.

JEAN JANNON (1580–1658)
The type designer who created the face on which most modern Garamond revivals are based. Jannon worked more than 80 years after Garamond and was the first to release revivals of the earlier Frenchman's work.

1530
Garamond's first roman type appeared in *Paraphrais in Elgantiarum Libros Laurentii Vallae*.

Type Timeline

Seventeenth century

WILLIAM CASLON (1692–1766)
An English gunsmith who became a type designer and founder of the Caslon Type Foundry, Caslon was also one of the very few wealthy type designers. His work was based on earlier Dutch designs and does not possess the irreproachable perfection of Bodoni or Baskerville. Caslon's strength as a type designer was not in his ability to create flawless letters, but to create a font of type that when set in a block of text copy appears perfect in spite of the vagaries of each letterform.

Eighteenth century

1734
Caslon types were first shown.

1762
The Baskerville typeface was first used.

JOHN BASKERVILLE (1706–1775)
He was cranky, vain, and scornful of convention. His peers disapproved of him, his type, and his printing. Baskerville was also an iconoclast of the first order. He lived with a woman for sixteen years before marrying her (something not unheard of in eighteenth-century England—but also not something approved by eighteenth-century British society). He built a mausoleum on his property to be used for his burial, because of his lifetime aversion to Christianity. Today Baskerville's unpopular type is one of the most popular and most used serif typefaces. It is represented in essentially every type library and can be reproduced on practically every kind of imaging device.

PIERRE SIMON FOURNIER (1712–1768)
This French printer and type designer's work predated Bodoni's and is really the foundation for of much of Bodoni's first typeface designs. Monotype Fournier and Barbou are based on Fournier's work, as is Dwiggins Electra.

GIAMBATTISTA BODONI (1740–1813)
The typography and type designs Bodoni created are still regarded as being among the most refined and elegant ever produced. But then he had the luxury of almost limitless time, money, and effort to spend on his projects. Bodoni was employed by the Duke of Parma and, outside of the occasional royal commission, only worked on projects that he wanted to do. Bodoni was also one of history's mostly prolific creators of type. He was a demanding and exacting typographer who wanted to be able to use exactly the size and proportion of type that best suited his needs. As a result he created literally hundreds of fonts—all in the Bodoni style. An 1840 inventory of his output showed over twenty-five thousand punches and over fifty thousand matrices!

Nineteenth century

1816
The first sans serif font was designed by William Caslon IV, the great-great-grandson of the William Caslon that gave us the English serif design.

1818
Bodoni
The quintessential modern type was shown in Giambattista Bodoni's *Manuale*, completed by his wife after his death.

1821

Italienne, one of the first commercially popular advertising display designs, was first used. Because its serifs are heavier than its main character strokes, this style of type has been called a "reversed Egyptian."

1844

Clarendon was first released by R. Besley & Co. Type Founders in England as a heavy face to accompany standard text composition in directories and dictionaries.

FREDERIC GOUDY (1865–1947)

One of America's most prolific and best-known type designers, as a type designer Goudy displayed originality and technical skill. He created more, and more diverse, typefaces than any designer before him. It is a testimony to Goudy's ability that so many of his designs are still in active use. Kennerly is available from a wide variety of sources. Goudy Oldstyle is a modern classic. Italian Old Style, National Oldstyle, Garamond, Deepdene, and even Goudy Sans are available as state-of-the-art digital fonts. Copperplate Gothic, which was an ATF best seller in fonts of metal, is also a Goudy design. And finally, ITC Berkeley Oldstyle is a revival of Goudy's University of California Old Style.

MORRIS FULLER BENTON (1872–1948)

The unknown father of American type design and the person behind American Type Founders' type development program for over 35 years, along with Fred Goudy and Ed Benguiat, Benton was one of America's most prolific type designers.

EMIL RUDOLF WEISS (1875–1943)

A leading German typographer, designer, and calligrapher, Emil Weiss was associated with the Bauer foundry in the 1930s and 1940s. His best-known design is the Memphis family.

RUDOLF KOCH (1876–1934)

Koch was primarily a calligrapher and teacher, but his association with the Klingspor type foundry in Germany provided the opportunity for a number of his designs to be made into fonts of type. Most famous for his sans serif design Kabel, he is also responsible for several other typefaces that have been made into digital fonts.

LUCIAN BERNHARD (1885–1972)

Lucian Bernhard never owned an automobile, radio, television, or virtually any other electrical appliance. He was a avid tango dancer and world-class admirer (our enlightened society might use harsher words) of women. Bernhard began designing typefaces as a young man in Germany. His first was cut in 1910. From then on he designed a typeface a year until he came to America in 1922 to work with American Type Founders, where he produced thirteen typefaces.

PAUL RENNER (1878–1956)

Creator of the first modern, geometric sans serif face: Futura. Although not a member of the Bauhaus, Renner shared its ideals and believed that a modern typeface should express modern models, rather than be a revival of previous a design. His original renderings for Futura's lowercase were much more experiential and geometric in character than those finally released by the Bauer foundry.

OZWALD COOPER (1879–1940)

Primarily a lettering artist and graphic designer, Ozwald Cooper was also responsible for designing a number of advertising display typefaces. All his type designs are patterned after his hand lettering. His best-known typeface, Cooper Black, started the twentieth-century trend in ultrabold typefaces and has been called a "design for farsighted printers and nearsighted readers."

WILLIAM ADDISON DWIGGINS (1880–1956)

An American graphic, typographic, and book designer, Dwiggins designed the typefaces Caledonia, Eldorado, Electra, Falcon, and Metro for Mergenthaler Linotype. Dwiggins' self-imposed challenge in all his type designs was to create beautiful and utilitarian typefaces for machine composition.

Type Timeline

ERIC GILL (1882–1940)
An English sculptor, stonecutter, artist, and type designer, Gill's most important work, and his only sans, is Gill Sans. Other designs include Joanna, Perpetua, and Pilgrim. A true iconoclast, Gill is also well-known for his radical political beliefs and sexual adventures.

VICTOR HAMMER (1882–1967)
Type designer Victor Hammer created American Uncial, his most famous design, in 1943.

STANLEY MORISON (1889–1967)
Though not a type designer, lettering artist, or calligrapher, Stanley Morison was one of the most influential figures in modern British typography. As typographical advisor to the Monotype Corp. for more than twenty-five years, he was responsible for the release of such classic designs as Rockwell, Gill Sans, Perpetua, Albertus, and—perhaps his most successful face—Times New Roman.

1892
American Type Founders was founded as a consortium of twenty-three individual type foundries. In the late 1800s the demand for type was intense, but because there were so many competing type foundries, each having to design, manufacture, market, and distribute its own fonts, the business of type was in a turmoil. ATF was founded as a venture to improve profit margins and restore stability to the type industry.

JAN VAN KRIMPEN (1892–1957)
A good type designer and one of the greatest book typographers of the twentieth century, his first and most successful type design was Lutetia, which he drew for the prestigious printing house of Enschedé en Zonen in the Netherlands.

GEORG TRUMP (1895–1985)
A teacher of graphic design and type designer primarily associated with the Weber foundry in Germany. His most important design was Trump Mediaeval, released in 1954.

CHARLES PEIGNOT (1897–1983)
Director of Deberny & Peignot for nearly 50 years, Charles Peignot was closely involved with the creation of all new faces emanating from his foundry. He commissioned the poster artist A. M. Cassandre to create the typeface that bears his name, Peignot. He was at the forefront of the fight for typeface copyright protection and helped found the Association Typographique International.

1898
Akzidenz Grotesk released
Akzidenz Grotesk was the great-great-grandparent of Helvetica, first issued by Berthold. It provided yeoman duty as what was then called a jobbing face for many years until it was replaced by the geometric sans serif designs of the 1930s.

ROBERT HUNTER MIDDLETON (1898–1985)
Type director for the Ludlow type foundry for almost 50 years, he devoted his entire professional life to the Ludlow company. By the time he retired, Middleton had created almost 100 typefaces, among them Radiant, Stellar, Karnak, and Record Gothic.

Twentieth century

1900
Century Expanded
In 1894, the Century type-face was cut by Linn Boyd Benton in collaboration with Theodore Low DeVinne for the *Century* magazine. Century Expanded is the first commercial family based on the original design.

MAX MIEDINGER (circa 1900–1980)
In the 1950s, under the direction of Edouard Hoffmann, Max Miedinger of Zurich, Switzerland, was asked to update Haas Grotesk, a version of Berthold's Akzidenz Grotesk, for the Haas foundry. His creation, New Haas Grotesque, was rechristened Helvetica.

BEATRICE WARDE (1900–1969)
Although she never drew a typeface, she was one of the most important women in modern typographic history. Warde provided the impetus behind the typo-graphical efforts of Monotype during its most impor-tant years from 1925 into the 1950s.

JAN TSCHICHOLD (1902–1974)
In the early part of this century Jan Tschichold revolu-tionized typography by virtually single-handedly mak-ing asymmetric typographic arrangement the style of choice among young designers. For many years, Tschichold created posters, book covers, advertise-ments, and even letterheads that were quintessential examples of asymmetric design.

1903
Named after Benjamin Franklin and originally issued in just one weight, the Franklin Gothic family was expanded over the years to include several designs.

1906
Century Old Style released
Morris Fuller Benton's Oldstyle addition to the Century family is an exceptionally successful melding of the Century typeface and Oldstyle design traits.

WARREN CHAPPELL (1904–1991)
An American type designer and typographic scholar, Chappell studied under Rudolf Koch in Germany and created typefaces for both American and European foundries. His works include Trajan, Lydian, and Lydian Cursive.

ROGER EXCOFFON (1910–1983)
French graphic and type designer who created, among other faces, Mistral in 1953 and Antique Olive in the 1960s.

1915
Goudy Oldstyle released
Although he was not totally satisfied with the design, this is the most consistently popu-lar of Fred Goudy's many typefaces.

1915
Century Schoolbook released
This design was a result of Morris Fuller Benton's research into vision and reading comprehension. It was conceived and widely used for setting of children's schoolbooks. The face also served as the foundation for the many "legibility" types that followed.

TONY STAN (1917–1988)
A prolific contemporary New York letter and type designer affiliated with PhotoLettering, Inc. and International Typeface Corp., Tony Stan has created and/or adapted a number of typefaces for such designs as ITC Berkeley Oldstyle, ITC Garamond, ITC Century, and ITC Cheltenham.

1917
First modern revival of Garamond released by American Type Founders

Type Timeline

FREEMAN (JERRY) CRAW (1917–)
Craw is an American graphic and type designer of both metal and phototype faces, among them Craw Clarendon, Craw Modern, and Ad Lib.

HERB LUBALIN (1918–1981)
An American graphic and typographic designer who broke new ground for creativity with his graphic design and typographic handling in the 1960s and 1970s and at the same time set a standard for graphic communication that was emulated by much of the graphic design community. In addition Lubalin was one of the founders of ITC and the creator of more than 200 alphabets.

HERMANN ZAPF (1918–)
One of the twentieth century's most important and prolific typeface designers, Hermann Zapf has created such universally acclaimed typefaces as Optima, Palatino, Melior, ITC Zapf Chancery, and ITC Zapf Dingbats.

ALDO NOVARESE (1920–1995)
An Italian type designer responsible for a variety of text and display designs, Novarese was associated early in his career with the Nebiolo type foundry in Turin and created faces primarily in conjunction with Alessandro Butti, among them Augustea and Microgramma (which later became Eurostile when he added a lowercase).

AARON BURNS (1922–1991)
A typographer and founder of International Typeface Corp., Burns' contribution to the typographic field— although he was not a type designer—is as significant as that of many of the most important and well-known creators of typefaces. Over six hundred original and revival typeface designs have been released, and many type designers were provided their first opportunity to create a commercial typeface design as a result of the company Burns founded.

1927
Kabel released
Named for the Transatlantic Cable, this geometric sans was designed by Rudolph Koch for the Klingspor type foundry.

ED BENGUIAT (1927–)
Benguiat has drawn over six hundred typefaces, possibly more than any other type designer. He has created revivals of old metal faces such as ITC Souvenir, ITC Bookman, and Sara Bernhardt, and he has drawn absolutely new and original designs such as Charisma, ITC Panache, and Spectra.

1928
Gill Sans released
Commissioned by Stanley Morison for Monotype, this Eric Gill design was intended to recover sales lost to the new German geometric sans serif typefaces.

ADRIAN FRUTIGER (1928-)

A contemporary Swiss graphic designer and typographer, Adrian Frutiger is one of the most important type designers of the post-World War period. He was asked by Deberny and Peignot to adapt Futura, but finding it too geometric chose instead to create a large type family with matching weights; thus Univers was born.

1929

Futura released

Drawn by Paul Renner, this was the first modern geometric sans serif typeface influenced by the Universal typeface drawn by Herbert Bayer and the Bauhaus design philosophy.

1929

Bembo released

The twentieth-century version of a typeface designed by Francesco Griffo for Aldus Manutius, the design was released by Monotype as part of Stanley Morison's typeface revival program.

1929

Memphis released

Memphis, the first twentieth-century slab serif design, was released by the Stempel Type Foundry. The similarities between Memphis and Futura are obvious.

1930

Metro released

Metro is the only sans serif type designed by William Dwiggins.

1932

Times Roman released

Commissioned by *The Times of London* newspaper, Times Roman's design was supervised by Stanley Morison, who provided the original Plantin specimens used to draw the face. The designer, Victor Lardent, an artist on the *Times* staff, was appointed by Morison.

FRIEDRICH POPPL (1932–1982)

A German type designer who worked primarily for the Berthold Type Foundry, his faces are best known in Europe; among them are Poppl-Pontifex and Poppl-Laudatio.

LESLIE USHERWOOD (1932–1983)

Leslie Usherwood began his career as a lettering artist in the field of commercial art. He founded Typesettra Ltd. in Toronto in 1968. The creator of Caxton, ITC Usherwood, and Flange, he specialized in hand lettering and headline typefaces.

MATTHEW CARTER (1937–)

The son of printing historian Harry Carter, Matthew Carter can be considered one of the founders of electronic type. The designer of Bell Centennial for Linotype and ITC Galliard with Mike Parker, he and Parker founded Bitstream in 1981 to design and market type in digital form. Carter is also a charter member of the "Type Mafia" (see 1980).

1938

Radiant released

This is a stressed sans released by Ludlow.

1938

Caledonia released

Mergenthaler Linotype released this typeface.

Type Timeline

TOM CARNESE (1939–)
Best known for his collaborations with Herb Lubalin at ITC, Tom Carnese has created or helped to create a number of popular fonts, including ITC Avant Garde Gothic, ITC Bolt Bold, and ITC Pioneer.

GERARD UNGER (1942–)
Unger is a Dutch type designer who has drawn several faces for the Enschedé type foundry in the Netherlands and Dr-Inf Rudolf Hell in Germany.

DAVE FAREY (1943–)
Farey is a British type designer who grew out of the Letraset school and has designed faces such as ITC Beesknees, ITC Ozwald, ITC Highlander, Aries, ITC Golden Cockerel, and the Creative Alliance revival of Stellar. He is a member of the "Type Mafia."

COLIN BRIGNALL (1945–)
Brignall is a British type designer and director of type development at Letraset. Although originally created for dry-transfer lettering, many of his faces have become standards of photo and digital typography. Some of his more important designs are Corinthian, Edwardian, Italia, Revue, Romic, and most recently, Retro. He is a member of the "Type Mafia."

SUMNER STONE (1945–)
An American type designer and former director of typographic development for Adobe Systems, his most important design to date has been the ITC Stone family of type, a series of serif, sans serif, and informal alphabets with common weights and proportions. He is a member of the "Type Mafia."

DAVID QUAY (1947–)
British type designer who drew ITC Quay Sans, and more recently Coptek, La Bamba, and Lambada for Letraset.

ERIK SPIEKERMANN (1947–)
A German type and graphic designer, Spiekermann has designed faces such as ITC Officina and Lo-Type and Berliner Grotesk for Berthold and is one of the principals of MetaDesign. He is a member of the "Type Mafia."

1948
Trade Gothic released by Mergenthaler Linotype

1950
Palatino released by Mergenthaler Linotype

KRIS HOLMES (1950–)
Holmes is an American type designer who has designed typefaces for Compugraphic Corp. and Dr-Inf Rudolf Hell in Germany. Some of her designs include ITC Isadora, Shannon (which she designed in conjunction with Janice Prescott), and Lucida (which she worked on with her business partner, Charles Bigelow).

1954
The first phototypesetting machine placed in a commercial business

1954
Trump Mediaeval released

DAVID BERLOW (1955–)
Berlow is an American type designer and proprietor of the Font Bureau, one of America's most prolific and creative type supply companies. Prior to opening the Font Bureau he was a type designer for Bitstream Inc. and Mergenthaler Linotype. He is a member of the "Type Mafia."

CYNTHIA HOLLANDSWORTH (1955–)
Hollandsworth is a type designer and an advocate for the protection of designer's rights. Her faces include Hiroshige, ITC Tiepolo, and Wile Roman. In 1987 she formed the Typeface Design Coalition, an association of type foundries and type designers whose common goal is the protection of typeface designs. She is a member of the "Type Mafia."

ROBERT SLIMBACH (1956–)
An American type designer who worked as a letter designer for Autologic, Slimbach was a freelance designer before joining Adobe Systems Inc. in 1987. Creator of ITC Slimbach, ITC Giovanni, Adobe Garamond, Utopia, Minion, Poetica, Adobe Jenson, Kepler, and several other faces.

1957
Helvetica released
Max Miedinger's revival of Akzidenz Grotesk was first released as New Haas Grotesk. The design was later changed to its present name in honor of its country of origin, Helvetica (Switzerland). Miedinger's first release included only three variants, but other styles and weights were added over many years by several designers.

1958
Optima released
This is Hermann Zapf's favorite typeface; he used it to set his own wedding invitation.

CAROL TWOMBLY (1959–)
A graduate of the Rhode Island School of Design and Stanford University, Twombly has worked at Bitstream and Adobe Systems Inc. Designs she is credited with include Mirarae (which won the Morisawa Typeface Design Competition in 1984), Charlemagne, Lithos, Trajan, Viva, and Nueva.

ZUZANA LICKO (1961–)
A Czechoslovakian designer who emigrated to the United States in 1968, Licko first created type designs to be used in the publication *Emigré*, but because they were met with so much enthusiasm by the young design community, the faces were eventually made into commercial fonts. Her more successful faces are Matrix and Variex.

1962
Eurostile released

1966
Sabon released
This Roman type designed by Jan Tschichold is important because it was the result of a joint design program on the part of Linotype, Stempel, and Monotype to create a face that was concurrently available as hand-set and machine-set metal type as well as phototype fonts.

1968
Compugraphic Corp., the company that made low-cost phototypesetting a practical reality, entered the phototypesetting machinery market.

Type Timeline

1969
International Typeface Corp. founded as a partnership of Lubalin, Burns, and PhotoLettering Inc. The idea was that Herb Lubalin and Aaron Burns would provide new typeface designs and the marketing to make them successful, while PhotoLettering Inc. would supply the technical know-how to produce artwork for phototype font development. ITC is a company that some hail as "the most creative and influential type foundry since ATF" and others deride as the McDonalds of typeface development. Both opinions may be correct.

1970
ITC Avant Garde Gothic released
The first typeface released by International Typeface Corp. was initially drawn by Herb Lubalin as the logo and headline face for *Avant Garde* magazine.

1970
ITC Souvenir released
The typeface designers love to hate was released. Originally developed by Morris Fuller Benton for ATF in 1918, Ed Benguiat revived the basic design, enlarged the family, and created the first italic variants.

1978
ITC Galliard released
Designed by Matthew Carter for Linotype but later licensed to International Typeface Corp. in 1982, ITC Galliard was based on a sixteenth-century design by Robert Granjon.

1980
This is the arbitrary date set for the founding of the "Type Mafia." Because of computer technology, fax machines, e-mail, and international design projects, the type design community is able to be in closer contact than ever before. The Type Mafia is a close-knit but informal group of friends and business associates who are the real power behind modern typeface design. Many, but not all members are listed in this timeline.

1983
Adobe PostScript announced.
This is one of the three most important technological advancements in typographic history, the first being Gutenberg's invention of the adjustable mold and the second the invention of the Higonnet-Moyroud phototypesetting machine.

1983
ITC Berkeley Oldstyle released

1985
Apple introduces the Macintosh and the LaserWriter printer. Aldus releases PageMaker 1.0, and Paul Brainard coins the term "desktop publishing."

1990

Tekton released
Possibly the ITC Souvenir of the 1990s, Tekton was designed by David Siegel for Adobe Systems Inc.

1992

First Adobe Multiple Masters font released
Multiple master technology enables the type designer to create master designs at each end of one, or more, predetermined design axes.
The graphic designer can then interpolate, or generate intermediate variations, between the master designs on demand.

1993

Apple announces TrueType GX
GX fonts were heralded as "smart fonts" that can automatically insert ligatures, alternate characters, and swash letters, in addition to providing the graphic designer with automatic optical alignment and other typographic refinements.
Unfortunately, because Apple didn't support them, Adobe didn't like them, and nobody could afford to make them, TrueType GX fonts never became popular.

1994

Nueva, a design by Carol Twombly, released by Adobe

1995

Agfa forms the Creative Alliance with more than 30 independent type designers and type suppliers.

1996

Agfa and Monotype announce the joint production of the Creative Alliance CD. Microsoft releases Word 97 with more than 150 free typefaces bundled. Berthold declares bankruptcy and Linotype-Hell is purchased by Heidelberg.

Adobe Jenson is released.

Glossary

Ampersand (&)
Symbol meaning "and," evolved from the Latin ligature for the word "et."

Arm
A horizontal stroke that is free on one or both ends.

Ascender
The part of the lowercase "b," "d," "f," "h," "k," "l," and "t" that extends above the height of the lowercase "x."

Bar
The horizontal stroke of the "e," "f," "t," "A," "H," and "T."

Baseline
An imaginary line on which the letters rest; descenders fall below the baseline.

Boldface
A heavier version of the normal weight of the typeface.

Bowl
A curved stroke that encloses a counter, except the lower portion of the two-storied lowercase g, which is called a "loop."

Calligraphy
A writing style based on flat-tipped pen or brush strokes.

Cap-line
An imaginary line that runs along the top of capital letters.

Characters
Individual letters, figures, punctuation marks, and special symbols.

Character Set
All the letters, numbers, punctuation marks, and special symbols that constitute a font.

Condensed
Classification of a typeface in which the letters are narrower than normal.

Counter
Fully or partially enclosed space within a letter.

Cursive
Typefaces resembling handwritten script.

Descender
The part of the letters "g," "j," "p," "q," and "y," that extends below the baseline.

Display type
Type that by its size or weight is used to attract attention; usually 14-point or larger.

Ear
The small stroke projecting from the right side of the upper bowl of the lowercase g.

Em
Normally a square measuring the same number of points on a side as a given point size of type. Can be narrower or wider depending on the proportions of the typeface used.

En
Half the width of an em.

Expanded
Classification of a typeface in which the letters are wider than normal.

Hairline
The thin stroke in a serif type design.

Headline
Usually the most prominent element of type in a piece of printing; that which attracts the reader to read further or summarizes at a glance the content of the copy which it accompanies.

Italic
Type in which the letters are obliqued; cursive typestyles are usually italic, but not all italics are cursive.

Leg
The bottom diagonal on the uppercase and lowercase "k."

Ligature
Two or more letters linked together as a single character.

Link
A stroke connecting the upper bowl and lower loop of the lowercase "g."

Lightface
A lighter version of a standard weight of the typeface.

Lining figures
Numerals the same height as the capitals in any given typeface: 1,2,3,4,5,6,7,8,9,0; lining figures align on the baseline. Also called "uppercase figures."

Loop
The lower portion of the lowercase roman "g."

Lowercase
Small letters; the term is derived from hand composition of metal type. When type was set by hand, two cases were used to hold the individual pieces of metal type, with one case placed higher than the other. The capitals were kept in the upper case and the small letters in the lower case.

Lowercase numbers
Numerals that vary in size, some having ascenders and others having descenders; these numbers normally correspond to lowercase proportions. Also called "old-style figures."

Old-style figures
Numerals that vary in size, some having ascenders and others having descenders; these numbers normally correspond to lowercase proportions. Also called "lowercase numbers."

Roman
Name often applied to the Latin alphabet as it is used in English and European languages; also used to identify upright, as opposed to italic or cursive, alphabet designs.

Sans serif
Classification of a typeface without serifs.

Script
Classification of a typeface designed to suggest handwriting or writing with a brush.

Serif
A line crossing the main strokes of a character; there are many varieties.

Shoulder
The curved stroke protruding from a stem.

Small caps
Letters the approximate size of lowercase x-height characters, but in the design of the capitals; normally available in text typeface designs only.

Spine
Main curved stroke of the capital and lowercase "s."

Spur
A small projection from a stroke.

Stem
A vertical or diagonal stroke.

Stress
The direction of thickening in a curved stroke.

Swash letters
Characters with fancy flourishes.

Tail
The part of a "Q" which makes it look different than an "O," or the diagonal stroke of the "R" which makes it look different than a "P."

Terminal
The end of a stroke not terminated with a serif.

Text
The body copy in a book or on a page, as distinct from the headings.

Text type
Main body type, usually smaller in size than 14 points.

Typeface
One of the variations of styles in a typeface family, such as roman, italic, bold, ultra, condensed, expanded, outline, contour, etc.

Type family
A range of typeface designs that are all variations of one basic style of alphabet. The usual components of a type family are roman, italic, and bold. These can also include variations in width (condensed or extended) and in weight (light to extra bold). Some families have many styles.

Uppercase
Capitals; see lowercase

Uppercase numbers
Numerals the same height as the capitals in any given typeface: 1,2,3,4,5,6,7,8,9,0; uppercase figures align on the baseline. Also called "lining figures."

x-height
The height of lowercase characters excluding ascenders and descenders; based on the height of the lowercase x.

Directory of Type Foundries and Designers

Adobe Systems Inc.
345 Park Avenue
San Jose, California 95110
408.536.4144
408.537.4008 (fax)

Agfa
90 Industrial Way
Wilmington, Massachusetts 01887
800.424.8973

David Berlow
The Font Bureau, Inc.
326 A Street
Boston, Massachusetts 02110
617.423.8770
617.423.8771 (fax)
www.fontbureau.com

Matthew Carter
36A Rice Street, Apartment 3
Cambridge, Massachusetts 02140
617.876.5447

Jean-Renaud Cuaz
Typorium
112 South Bench Street
Galena, Illinois 61036
815.777.3309
815.777.9435 (fax)
typorium@aol.com

Dave Farey
Housestyle Graphics
50-54 Clerkenwell Road
London EC1M 5PS
United Kingdom
0171.251.3746
0171.253.7066 (fax)

The Font Bureau, Inc.
326 A Street
Boston, Massachusetts 02110
617.423.8770
617.423.8771 (fax)
www.fontbureau.com

Tobias Frere-Jones
The Font Bureau, Inc.
326 A Street
Boston, Massachusetts 02110
617.423.8770
617.423.8771 (fax)
www.fontbureau.com

Jonathan Hoefler
The Hoefler Type Foundry Inc.
611 Broadway, Room 815
New York, New York 10012
212.777.6640
212.777.6684 (fax)
info@typography.com
www.typography.com

James Montalbano
Terminal Design, Inc.
125 Congress Street
Brooklyn, New York 11201
718.246.7069
718.246.7085 (fax)
jatermd@interport.net

Jim Parkinson
Parkinson Type Design
6170 Broadway Terrace
Oakland, California 94618
510.547.3100
510.547.1400 (fax)
parkinson@typedesign.com

Jean-François Porchez
Porchez Typofounderie
38 bis avenue Augustin-Dumont
F-92240 Malakoff
France
33.0.1.46.54.2692
www.porcheztypo.com

David Quay and **Freda Sack**
The Foundry
Studio 12
10-11 Archer Street
London, W1V 7HG
England
171.73.46.925
171.73.42.607 (fax)
dqfs@the foundrystudio.co.uk

Robert Slimbach
Adobe Systems Inc.
345 Park Avenue
San Jose, California 95110
408.536.4144
408.537.4008 (fax)

Erik Spiekermann
MetaDesign
Motzstrasse 58
D-10777 Berlin
Germany
49.30.21473027
49.30.213.9746 (fax)
erik@metadesign.com

Sumner Stone
Stone Type Foundry Inc.
626 Middlefield Road
Palo Alto, California 94301
415.324.1870
415.324.1783 (fax)

Carol Twombly
Adobe Systems Inc.
345 Park Avenue
San Jose, California 95110
408.536.4144
408.537.4008 (fax)

Index

Index

Index

Index